Photography and Japan

exposures

EXPOSURES is a series of books on photography designed to explore the rich history of the medium from thematic perspectives. Each title presents a striking collection of approximately 80 images and an engaging, accessible text that offers intriguing insights into a specific theme or subject.

Series editors: Mark Haworth-Booth and Peter Hamilton

Photography and Japan

Karen M. Fraser

reaktion books

Published by Reaktion Books Ltd
33 Great Sutton Street
London EC1V ODX
www.reaktionbooks.co.uk

First published 2011

Printed and bound in China by Eurasia

British Library Cataloguing in Publication Data
Fraser, Karen.
 Photography and Japan. – (Exposures)
 1. Photography – Japan – History
 2. Photography – Social aspects – Japan – History.
 I. Title
 II. Series
 770.9'52–DC22

ISBN 978 1 86189 797 8

Contents

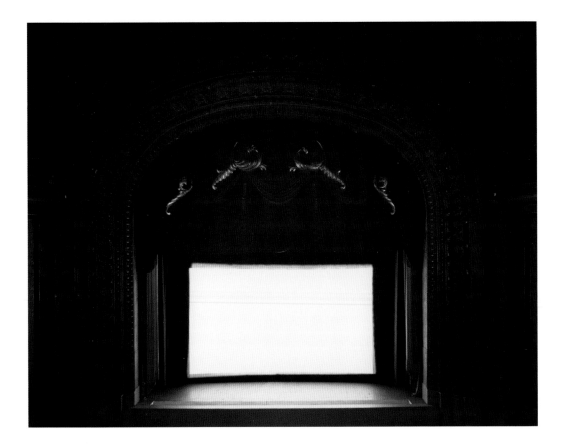

Introduction: Photography in Japan

Interpreting artistic production through the lens of nationality is a tricky proposition. This is particularly true when it comes to Japanese photography.

Writing about Japanese culture often draws on stereotypical assumptions. One common view holds that the Japanese have an 'innate' connection to nature that is manifested in Japanese visual culture. Another posits that Japanese art is imbued with a mystical Eastern spirituality, reflecting the country's Zen Buddhist traditions. When Japanese artists exhibit abroad, criticism and reviews of their work frequently focus on nationality as a defining feature and take one, or both, of these routes to suggest that it reveals an inherent 'Japanese-ness'. Japanese writers, too, often fall prey to these tendencies. Such approaches are essentialist and overly simplistic for interpreting any artistic form, but they are particularly complicated by the medium of photography. For the camera was and is a great equalizer: the equipment necessary (cameras, lenses, enlargers, chemicals) and processes used have been essentially the same, regardless of geographic location. And the sheer variety of genres and functions of photography – from 'high art' to vernacular, documentary and street photography – would seem to defy any straightforward categorization along nationalized aesthetic lines.

Indeed, setting aside the issue of what might comprise a Japanese photographic aesthetic, the notion of defining Japanese photography itself is problematic as well. As Naoyuki Kinoshita and others have commented, the very concept of 'Japanese' photography is ambivalent.[1] Does it refer only to photographers who hold Japanese nationality? If a

1 Hiroshi Sugimoto, *Metropolitan Palace, Los Angeles*, 1993, gelatin silver print.

Japanese-born artist photographs, say, a Parisian street scene, is this still 'Japanese' photography? And what of the many foreign photographers who have worked in Japan, from Felice Beato to Nan Goldin? Are their images of Japanese people and places considered 'Japanese' photography? Julia Adeney Thomas has addressed such questions as they pertain to one of the most widely recognized contemporary photographers, Hiroshi Sugimoto (illus. 1). Born in Japan, Sugimoto attended art school in Los Angeles in the early 1970s and has lived since then primarily in New York City, thus spending the majority of his adult life and working career based in the United States. Many of his photographs, including well-known series such as 'Seascapes' and 'Theaters', bear no clear connection to anything Japanese. Despite these factors, Sugimoto's work has often been interpreted as conveying an innately Japanese perspective. Thomas astutely notes that ultimately such interpretations are a form of savvy marketing, packaging the photographer into a tidy preconceived cultural framework that serves the needs of a global audience more than accurately analysing the work in question.[2]

The underlying thesis of this book is that it is virtually impossible to define the broad and varied world of Japanese photography by a specific and limited set of visual or nationalistic characteristics. Certainly there are individual photographers and movements whose work shares aesthetic qualities found in other Japanese visual arts, photographers who have emphasized the abstraction and asymmetry that characterize certain genres of traditional painting or who employ long focal lengths to create a compressed and flattened space approximating that seen in typical woodblock prints. But it is exceedingly difficult to speak of an innate or typical Japanese style for a medium that has, from its inception, been so incredibly diverse and eclectic. Japanese documentary photography, for instance, is surely more stylistically akin to documentary photography in other countries than to other genres within Japanese photography. More than any distinctive Japanese aesthetic, it is the specific subject-matter and social context of the images that define such work as being part of the Japanese photographic tradition. Ken Domon's objective documentation of the atomic bomb victims of Hiroshima in the 1950s, the forceful energy of Daidō Moriyama's photographic books in the late

1960s and '70s, the intensely personal imagery of Yurie Nagashima and other girl-photographer photo-diarists of the 1990s: each of these is intimately connected to a specific moment in Japanese cultural history (illus. 2).

Over the past 150 years, Japan has experienced some of the most significant events in modern history, including a remarkable transformation from an isolated, feudal country into an industrialized, modern world power during the Meiji period (1868–1912), an equally dramatic rise and fall as an imperial power in the first half of the twentieth century and a miraculous economic recovery in the two decades following the devastation of the Second World War. The history of photography within Japan has paralleled these events, becoming inextricably linked with notions of modernity and cultural change from the time it first arrived.[3] Rather than searching for an overarching aesthetic approach or attempting to define a singular 'Japanese photography', the story of photography and Japan is more appropriately told by investigating the relationship between photographic imagery and this dynamic social history. This book aims to elucidate that what is distinctive about Japanese photography is the intersection of this ever-evolving technology with social history, with the use of the camera to document key cultural and political events of the past century and a half and to explore social responses to cultural change. It explores Japanese photography from its origins in the 1850s to today through the lens of three key topics: 'Representation and Identity', 'Visions of War' and 'Picturing the City'. Each of these themes has played a prominent role in shaping Japanese history since the mid-nineteenth century and each has provided frequent subject-matter for photographers.[4] The book focuses primarily on Japanese photographers and on their Japanese subjects, but does not exclude images made by Japanese immigrants on non-native soil nor those taken by foreign photographers within Japan. A project of this scope by necessity can only select the work of a limited number of photographers. The images and artists included here have been chosen because their work is easily woven into these three overarching narratives.

Overview of Photography in Japan

The Early Years, 1850s–90s

The arrival of photography in Japan is well chronicled. Records kept by the Nagasaki merchant Toshinojō Ueno indicate that he received a shipment that included a daguerreotype camera in 1843, just a few years after the introduction of the process in France.[5] Notably, Japan was officially closed to the West at this time. It was still ruled by the Tokugawa shogunate (military rulers), who enforced a policy of national seclusion from 1639 to the mid-1850s that severely restricted foreign access into Japan and closely controlled all foreign trade through the port of Nagasaki. For reasons unknown the first imported camera did not remain in Japan, but another one arrived five years later. It was destined for the Satsuma clan in the Kagoshima domain, located relatively close to Nagasaki in Kyushu, the southernmost of Japan's four main islands. The Satsuma *daimyo* (feudal lords) were particularly interested in Western science and technology. When Nariakira Shimazu became the *daimyo* in 1851, he and his scholarly retainers experimented with the camera, but not having ready knowledge of the complex process required to produce an image, it took them several years to achieve any success. The 1857 portrait of Shimazu is the first known daguerreotype taken by a Japanese photographer and the oldest extant native photograph known (illus. 3).

The arrival of the American commodore Matthew Perry in 1853 to coerce a Japanese trade treaty began the opening of Japan. Most images of the 1850s and early 1860s were taken by foreign photographers who came to help usher in or profit from that process, which occurred slowly at first during the *bakumatsu* (end of military rule) phase of 1854–68 and then much more rapidly after the official beginning of the Meiji period in 1868. Early foreign photographers included Pierre Rossier, Baron Raimund von Stillfried and Felice Beato; they, in turn, taught the earliest professional Japanese photographers. Hikoma Ueno, Renjō Shimooka and Kuichi Uchida were among the important first-generation Japanese photographers, with Ueno and Shimooka opening studios in 1862 in Nagasaki and Yokohama, respectively, and Uchida opening a studio in Osaka in 1865 (illus. 4).[6] The earliest uses of photography in Japan

2 Yurie Nagashima, 'Untitled', from *Empty White Room*, 1993–4, c-print.

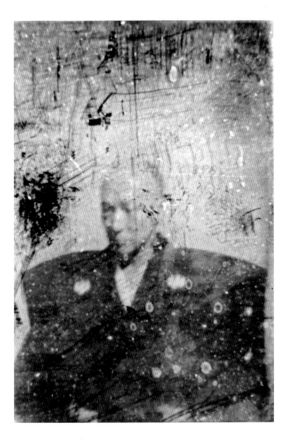

mimicked those found elsewhere and included both portraiture and landscape. Documentary photography recorded a variety of events: war, the aftermath of natural disaster, the physical transformation of the nation as it adopted Western-style architecture and new inventions such as trains, telegraph lines and gas lamps. A thriving industry also developed with the genre known as Yokohama photographs, stereotypical views of scenery and traditional customs and manners sold as tourist photography (see illus. 20 and 21).[7]

The nomenclature adapted for the photographic process provides a telling indication of early beliefs. The roots of the word photograph in English equate it to light writing. The Japanese term, *shashin*, translates as 'truth copy' or 'reflecting truth'. The earliest rhetoric surrounding the

4 Renjō Shimooka, *Geisha Standing Holding a Shamisen*, c. 1870, albumen print.

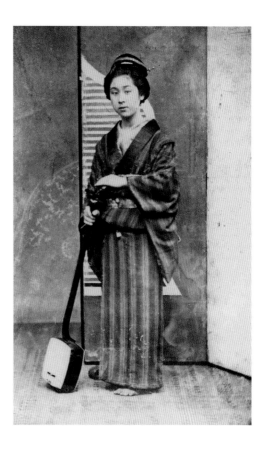

medium thus situated photography as a direct copy of the 'truth'.[8] In tandem with this understanding, most nineteenth-century photography might be classified as 'straight' photography: it was largely perceived to present the faithful recording of people and places. Though certainly there were ideological forces at work shaping what was photographed and how it was presented, there was little deliberate manipulation of the technical processes or experimentation with art photography as in the West. Given the connection between photography and Western science and this belief in the camera's capacity for veracity, the earliest photographers were considered scientists rather than artists. Like Shimazu and his retainers, the very first photographers were scholarly amateurs supported in their research by their feudal lords. Once photography

really started to take root in the 1860s and spread widely in the 1870s, it was practised primarily by professionals in commercial settings. The term for photographer in use throughout the nineteenth century, *shashinshi*, indicates that they continued to garner respect for their skills. It implied a sophisticated mastery of a field, with the character '*shi*' being shared by other esteemed professions such as teacher and doctor.

In this first phase, technological developments tended to reach Japan with a delay of a decade or two, a fact that dictated the processes Japanese photographers used, as technologies changed rapidly for the first 40 or so years. The daguerreotype never made significant inroads in Japan, for example; by the time photography was becoming more widespread, that process was already dated. Instead early Japanese portraits tended to be *carte-de-visites* or ambrotypes.[9] The gap in adapting new technology gradually diminished, and eventually disappeared around the turn of the century. As the Japanese camera and photographic industry started to grow, the Japanese no longer lagged behind technologically.[10]

The Age of Art Photography, 1890s–1920s

While commercial photography continued to flourish, the first major stylistic shift away from the straight photography tradition occurred around the turn of the century. This was the advent of *geijutsu shashin*, or art photography, a term often synonymous with Pictorialism (*geijutsu* has the connotation of 'fine art' in Japanese). There were some early photographers who experimented with different artistic formats. Matsusaburō Yokoyama, for instance, combined photographs with oil painting by the 1880s, and hand-painted images were standard in the tourist photography genre (illus. 5; see also illus. 20, 21). Generally colour was added in these cases to enhance the effects of realism. However, it wasn't until 1893 that the broader Japanese photography world started to embrace the concept of art photography. That year, a Tokyo exhibit organized by the British photographer and engineer William K. Burton introduced European-style Pictorial photography to Japan, inspiring the artistic photography movement.[11]

The Japanese photographers who first joined this movement focused their efforts on creative printing techniques, emphasizing the manipulation of the pigment during the printing process to create artistic effects using materials such as gum bichromate, carbon and bromoil (see illus. 85). This resulted in works that are often reminiscent of other Japanese artistic media, notably woodblock prints and ink paintings. Much early art photography took landscape as its subject-matter, and often photographers sought to mimic traditional landscape

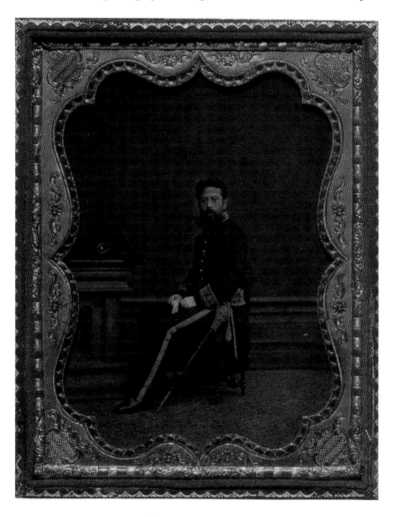

5 Matsusaburō Yokoyama, *Portrait of a Man in Military Uniform*, c. 1880s, oil-painted photograph.

imagery as closely as possible. Indeed, of all the movements in Japanese photographic history, early twentieth-century art photography is perhaps most distinctively Japanese in its aesthetic, with this focus on simulating the appearance of traditional media. Pictorial-style artistic photography later expanded to include experimentation with dramatic lighting and composition as well. Well-known art photographers included Shinzō and Rosō Fukuhara, sons of the founder of the Shiseidō Company (see illus. 34).

While there were professionals who engaged in art photography, the movement was dominated by a new class of amateurs. Unlike the elite scholars who had experimented with photography at the end of the feudal age, these amateurs were part of an emerging middle class. The art photography movement coincided with the cultural and economic prosperity of the Taishō Democracy, which lasted from the early 1900s until the escalation of Japanese militarism in the early 1930s.[12] During these decades Japanese society prospered economically and culturally, emerging from the Meiji period having successfully achieved the goals of rapid modernization and industrialization. As the general standard of living improved and gave rise to increased leisure time, photography was one activity taken up by the new bourgeoisie. In the 1890s amateur photographic practice was still somewhat confined to the wealthier ranks of society. However, the introduction of roll film and the development of small, portable cameras allowed more people to dabble in hobby photography by the end of the Meiji period and, by the 1920s, cheap cameras and widely circulated how-to manuals helped make photography a widespread activity among the thriving middle class.[13]

Two phenomena accompanied and aided the growth of art photography: the proliferation of photography periodicals, made possible by innovations in printing technology at the turn of the century, and the advent of private camera and photography clubs.[14] Numerous magazines and journals focusing on art photography appeared, giving voice to the amateur hobby movement and marking it as a suitable intellectual pursuit for the middle class. Photography groups sprung up around the country, providing a forum for both amateurs and professionals to share ideas and facilitating the display of art photography through both exhibitions

6 *Tokyo Shayūkai* (Tokyo Photography Circle), page from the photo-book *Kage (Shadow)*, 1903.

and publications (illus. 6). Influential groups included *Yūtsuzusha* (The Morning Star Group), founded in 1904, which was especially interested in foreign photography and had a major influence in spreading the art photography movement. Founding member Seiichi Katō and others initiated *Tokyo shashin kenkyūkai* (Tokyo Photographic Research Society) in 1907, which became an important exhibition venue for art photography. Their so-called 'Kenten' exhibits began in 1910 and attracted entries from around the country.[15] This widespread popularity meant that Pictorial-style art photography lingered on through the early Shōwa period (1926–89), flourishing along with several other artistic styles in the later 1920s and '30s.

Later Modernism and Imperial Japan, 1920s–45

From the late 1920s to the end of the Second World War multiple photographic genres coexisted. Styles included Pictorialism, Modernist avant-garde photography, realism and propaganda, with the latter two dominating the war era from circa 1937–45. The art photography movement's emphasis on experimental printing processes eventually brought about a desire for a more straightforward representation of subject-matter. Critics viewed the Pictorialist tendency towards artistic manipulation as a dramatic departure from the roots of *shashin,* the 'truth telling' capabilities of the camera. In turn, a socially engaged, documentary-style realism developed which embraced a more direct exploration of subject-matter. Ken Domon, Kineo Kuwabara and Ihee Kimura emerged as some of the most important young photographers in this Social Realist movement (illus. 7). As Japan became increasingly aggressive in the 1930s, culminating in Japanese involvement in the Pacific War beginning in 1937, this more direct approach became employed to support government propaganda. Even when their images were used as explicit propaganda, however, Ryūichi Kaneko suggests that photographers such as Domon still expressed the 'spirit of realism', which would later come to full maturity in the photojournalism of the 1950s.[16]

More progressive artists and groups also pushed back against Pictorialism, which they perceived as being overly sentimental and romanticized. Rather than documentary photography, these groups promoted avant-garde styles inspired by European Modernist photography and influenced by such artists as Man Ray and László Moholy-Nagy. These new directions included *Shinkō shashin* (New Photography) and Surrealism. New Photography, like photojournalism, strove for a more straightforward recording of subject-matter. The influential essay *'Shashin ni kaere'* (Return to Photography) articulated the philosophy of the movement. Written by the critic Nobuo Ina, it was published in the second issue of the short-lived but extremely influential Modernist journal *Kōga* (Light Pictures).[17] Ina drew on the tenets of German New Objectivity to advocate a style that embraced the unique qualities specific to photography rather than attempting to imitate other artistic forms.

7 Kineo Kuwabara, *Tokyo in the 11th year of Showa, Rokku, Asakusa Park*, 1937, gelatin silver print.

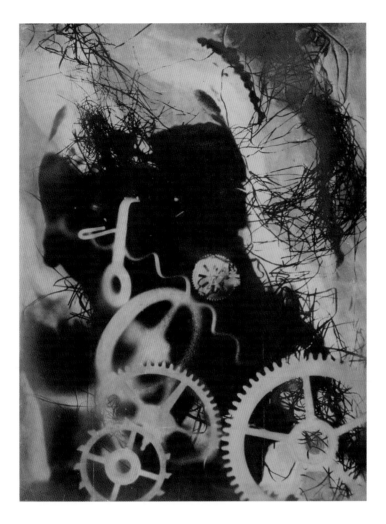

New Photography aimed to eliminate anything subjective or personal, emphasizing instead the mechanical nature of photography and often focusing on mechanical objects and symbols of technology as subject-matter (see illus. 86). Surrealism continued the practice of manipulating the artistic process, but with effects quite different than those of Pictorial art photography, such as photomontage and photograms (illus. 8). As with the earlier art photography movement, there were a number of thriving photography groups and clubs promoting Modernist photography along

with a flurry of photography publications (illus. 9). Other pictorial magazines incorporating striking graphic design and photomontage included the propagandist mouthpieces *Front* and NIPPON, founded by Yōnosuke Natori in 1934 and used to promote Japanese culture to the West as Japan became increasingly militaristic (see illus. 37, 38, 67 and 68).

The Postwar Era, 1945–70s

The atomic bombs dropped on Hiroshima and Nagasaki in August of 1945 and the subsequent surrender by the Japanese to the Americans dramatically ushered in the postwar era. Following the Allied Occupation from 1945–52, Japan made a surprisingly quick economic recovery from

9 Front cover and pages from *Shinkō shashin no tsukurikata* (How to Make Modern Photography) (1932).

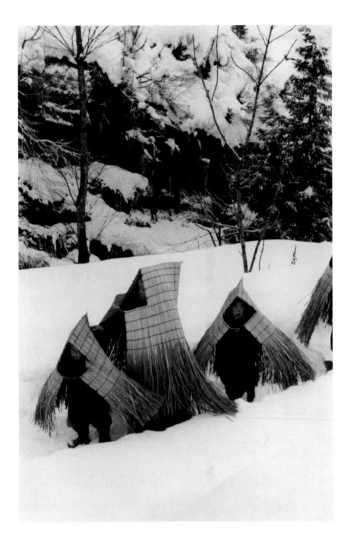

10 Hiroshi Hamaya, 'Children Walking to Honyara Cave', illustration from the photo-book *Snow Land*, gelatin silver print, 1956.

the complete devastation of the war, symbolized by the triumph of the 1964 Tokyo Olympics. Documentary photography continued to be produced in the immediate post-war period, and the dominant trend of the 1950s was photographic realism, with Domon, Kimura and Hiroshi Hamaya three of the leading proponents (illus. 10, 11). Domon's widely circulated quote that photographers should capture 'the absolutely pure snapshot, absolutely unstaged'[18] served as a guiding principle for many photographers in the first decade after the war. Here the photographer's role was to objectively and passively record events. The desire to use

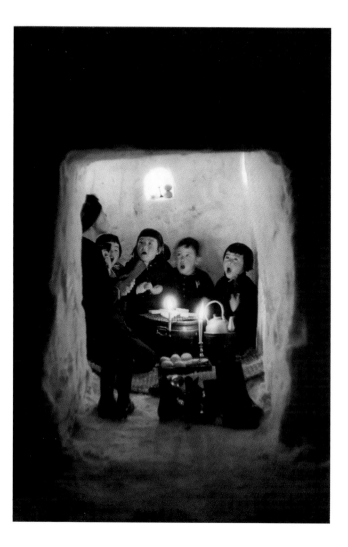

11 Hiroshi Hamaya, 'Children Singing in Honyara Cave', illustration from the photo-book *Snow Land*, 1956.

photography in a straightforward, unmediated manner that focused on depicting social concerns was an understandable reaction in a country emerging from a period of fascism, where images had previously been manipulated to serve the state's agenda. Indeed, Domon's high-profile endorsement for straight, 'honest' photography likely represented an effort to make amends for having participated in the propaganda machine himself.[19] But the straightforward photorealism of the early 1950s started to be supplanted by a much more dramatic aesthetic over the next decade.

By the late 1950s a more subjective style began to emerge. The photographers of the so-called 'Image Generation' deliberately challenged the photorealists, advocating a much more personal, engaged and expressive approach. They believed that the photographer's role was not merely to record, but to interpret, which they did with varied techniques and often striking creativity. The 1957 Tokyo exhibition 'The Eyes of Ten', organized by the critic Tatsuo Fukishima, brought together young photographers working in this new idiom, including Shōmei Tōmatsu, Eikoh Hosoe, Kikuji Kawada and Ikko Narahara (illus. 12). Along with Akira Satō and Akira Tanno, they formed a collective called Vivo in the summer of 1959, modelling themselves on the press agency, Magnum Photos, and sharing darkroom and office space. The Vivo artists were interested in both unorthodox subject-matter and printing techniques. The group remained active for just two years, but it played an important role in furthering this more experimental style.

The spirit of individualism advocated by the Vivo artists found expression a decade later in yet another loosely organized group, the Provoke collective, formed in 1968. This group included Kōji Taki, Yutaka Takanashi, Takuma Nakahira and the writer Takahiko Okada, with Daidō Moriyama joining soon after.[20] They founded a small journal to publish their work, *Provoke: Shisō no tame no chōhatsukei shiryō* (Provoke: Provocative Resources for Thought). The Provoke artists, too, wanted to challenge conventional ideas of photography. They strove to create a new visual language, one that would mediate between text and image and push the technical and conceptual boundaries of the medium. The result was a vibrant new aesthetic employing rough, blurred and out of focus photos (or *are-bure-boke,* a phrase with unclear origins that became the standard description for the Provoke style). Although this group was also short-lived, Provoke's influence was significant. Indeed, if one is compelled to define the most distinctive work in Japanese photography, the dramatic, energetic and distorted style of much photography from the 1960s and '70s fits the bill better than almost any other era; many contemporary commentators consider this period the quintessential expression of Japanese photography (see illus. 93, 95). Though work like this was certainly not unknown in other countries (the movement in fact

12 Ikko Narahara, '*Tokyo, the '50s', #42,* 1954–8, gelatin silver print.

drew inspiration from foreign photographers such as Robert Frank and William Klein), in Japan this aesthetic was especially powerful. It seemed particularly adept in capturing the societal tensions of post-war Japanese life while poignantly expressing the era's complexity: a country coming to terms with its recent wartime past while simultaneously experiencing the unsettling effects of a pervasive consumerist American influence. Although certainly not every photographer focused explicitly on this theme, it is not difficult to read such an interpretation into many works of the era.

Another key aspect of the post-war era was the flourishing of the photographic book.[21] Though photography publications had played an important role since the nineteenth century, the photo-book became the preeminent format used by Japanese photographers in the 1960s and '70s. In part this stemmed from the difficulties of finding suitable exhibition space: showing images in print conveniently circumvented the challenges presented by traditional means of displaying art. A key influence on book production was William Klein's pivotal book *Life is Good and Good for You in New York: Trance Witness Revels* (1956), which was well known in Japan by the early 1960s. The emphasis on the role of the photographer in constructing a narrative helped to establish serialized photography as the representative artistic form. A single *are-bure-boke* image might very well be incomprehensible, but a sequence of photographs could collectively express a story. Among the dozens of important photo-books from this period, the most significant include: *Hiroshima* (Ken Domon, 1958); *Hiroshima-Nagasaki Document 1961* (Domon and Shōmei Tōmatsu, 1961); *<11:02> Nagasaki* (Tōmatsu, 1966); *Chizu* (The Map, Kikuji Kawada, 1965); *Shashin yo Sayonara* (Farewell Photography, Daidō Moriyama, 1972); *Sentimental Journey* (Nobuyoshi Araki, 1971); and a trio of books by Eikoh Hosoe: *Kamaitachi* (1969), *Otoko to Onna* (Man and Woman, 1961) and *Barakei* (Ordeal by Roses, 1963) (illus. 13–14).[22] Hosoe's books highlight another feature of the era as well, the close ties between photographers and members of the avant-garde from other artistic fields. Both *Kamaitachi* and *Barakei* were, in essence, collaborative performance pieces, the former with the dancer Tatsumi Hijikata, founder of Ankoku butoh ha (School of Black Dance), and the latter with the writer Yukio Mishima.

Contemporary, 1980s to Today

Photography in contemporary Japan, like photography around the world, is incredibly diverse and difficult to categorize as a whole. To list just a few key trends: one major tendency in the last several decades is towards work that is staged and/or manipulated. Photographers such as Yasumasa Morimura (see illus. 54) have produced elaborately constructed images that defy easy classification and continue to challenge the conventions of the medium. Another trend is to blow up the image, with large-scale photographs creating dramatic exhibitions and often being incorporated in multimedia installations (Miwa Yanagi and Mariko Mori come to mind). Social commentary is an important element for many photographers. Morimura, Mori and Yanagi all have produced series that touch on gender issues within contemporary society, for example, as have artists such as Ryoko Suzuki and Ryudai Takano, both of whom have addressed issues of beauty and sexuality in recent works (illus. 15).[23] The photo-book genre still thrives. Established photographers such as Nobuyoshi Araki, Daidō Moriyama and Shōmei Tōmatsu continue to produce books, joined by the so-called 'girl photographers' of the 1990s and many other contemporary photo-diarists. Indeed the shelves of any decent-sized bookshop in Japan will have dozens of contemporary photo-books. For the first time, female photographers have a significant presence in the photographic world, with women gaining widespread recognition both in Japan and abroad. In the era of globalization, foreign photographers like Lee Friedlander and Nan Goldin have produced work in Japan, while Japanese photographers have gained increasing recognition internationally. Other characteristics shaping contemporary photography include the use of digital technology (both digital cameras and digital manipulation in the printing process), vibrant colour (often also digitally enhanced) and the fact that many photographers spend time abroad as part of their formative artistic training.

One of the most significant developments for the contemporary Japanese photography world has been the increasingly supportive institutional culture for the medium.[24] Historically photography attracted little attention from museums, which tended to focus on collecting and

following pages:

13 Eikoh Hosoe, illustration from the photo-book *Barakei* (Ordeal by Roses), 1963/1985, silver gelatin print.

14 Eikoh Hosoe, illustration from the photo-book *Barakei*, 1963/1985.

15 Ryudai Takano, *Long Hair Nesting on a Pink Cloth*, 2002, c-print.

exhibiting more traditional artistic genres. But in the last two decades photography departments in major museums have begun to expand and a number of museums specifically dedicated to photography have opened. Foremost among these is Tokyo-to shashin bijutsukan (the Tokyo Metropolitan Museum of Photography), which opened in its permanent location in Ebisu in 1995. Beyond serving as an important venue for photography within Japan, this museum has played a key role in helping to promote knowledge of Japanese photography abroad. Many of the exhibitions are accompanied by high-quality illustrated catalogues, which generally include English-language translations of key essays, making them more accessible to those unable to read Japanese. There are also museums dedicated to individual photographers, such as the Ken Domon Museum of Photography in his hometown of Sakata, opened in 1983 (the first Japanese museum devoted solely to photography) and the Shōji Ueda Museum of Photography, opened in 1995 (illus. 16). Together with this vastly expanded museum support, there is a thriving gallery culture. Artists who wish to exhibit their work often resort to the rental gallery system, where one purchases time in a small gallery space. Increasing institutionalization has also taken the form of expanded university photography programmes and the establishment of prestigious annual prizes. These include the Ihee Kimura prize given by the Asahi Shimbun Company, publishers of both the *Asahi Shimbun* newspaper and *Asahi Camera* magazine, and the New Cosmos of Photography competition, sponsored by Canon.

Trends in Japanese Photography

As even this brief survey makes clear, the history of photography in Japan is marked by an immense diversity of styles and trends. Despite the variety of photographic practices, however, there are several key elements that run throughout much of this history. These qualities help to define what is distinctive about Japanese photography.

One overarching characteristic is a continual engagement with the West. Since foreign photographers first started to arrive in the 1850s, the

development of Japanese photography has been stimulated by Western photographers and imported practices. The earliest photographers were taught by such foreigners as the Dutch amateur J.L.C. Pompe van Meerdervoort, who helped Hikoma Ueno master the collodion wet-plate process while stationed in Nagasaki (Ueno went on to write the first Japanese-language manual on the procedure). In the 1860s Felice Beato laid the foundations of Yokohama photography, which took its name from the city of Yokohama, one of the first ports open to foreigners. Japanese photographers such as Kimbei Kusakabe would later enjoy great success as the main purveyors of this tourist photography genre at the end of the nineteenth century.[25] As early twentieth-century art photography gave way to New Photography and Surrealism, these movements too benefited from an influx of Western photographs within Japan, circulated in exhibitions and various publications. In addition to Man Ray and Moholy-Nagy (previously mentioned), Edward Weston,

16 Shōji Ueda, *My Mother*, 1950, gelatin silver print.

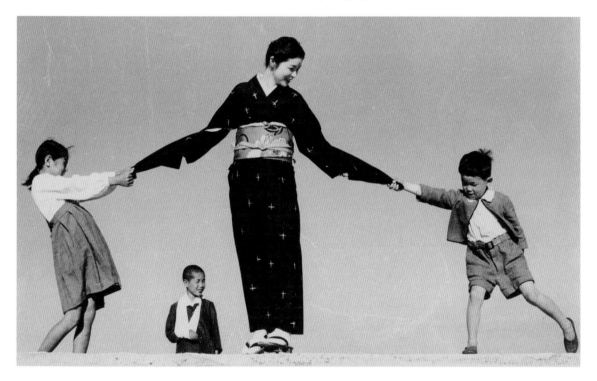

Paul Strand and André Kértesz were all leading foreign proponents of Modernist photography that figured in the Japanese dialogue. Sometimes foreign photographers had direct connections to Japanese individuals, who in turn brought their work to the attention of their colleagues. Iwata Nakayama, for instance, spent most of the 1920s working in New York and then Paris (illus. 17). As a founding member of the Ashiya Camera Club after his return to Japan, he arranged for a loan of Man Ray photograms through his friends abroad for the club's first exhibition, held

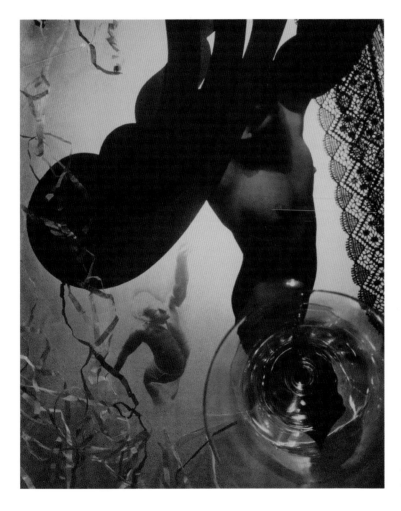

17 Iwata Nakayama, *Composition (Nude and Glass)*, 1935, gelatin silver print.

in Kobe in 1930.[26] And William Klein, whose work was so influential to the Vivo and Provoke-era photographers, spent six weeks in Japan in 1961, producing the book *Tokyo* (1964).

However, Japanese photographers have seldom merely mimicked these outside influences; rather they 'Japanified' them, whether by the choice of subject-matter, the intersection with social context or the unique adaptations made by native artists. Often the resulting images merge ideas borrowed from Western photography with Japanese design elements or themes. Nineteenth-century Japanese photographers opened portrait studios that appropriated the settings and poses seen in Western photographic portraits, for example, but sometimes placed their sitters in front of backdrops featuring Japanese symbols or scenery. The turn-of-the-century art photography movement was directly inspired by the Western Pictorialist tradition, but Japanese art photographers focused on Japanese-style landscapes. And the periodical *NIPPON*, perhaps the finest visual manifestation of Japanese nationalism, drew its inspiration from European Modernist photography publications, yet was 'Japanified' via its distinct subject-matter, elegant design and the traditional accordion-style binding used in the special book edition published in 1937.

In addition to foreign influences entering Japan, Japanese photographers have a long tradition of travelling abroad. The leading nineteenth-century commercial photographer Kazuma Ogawa went to the United States in 1882 to learn the latest printing techniques, including collotype and dry-plate photography. Art photographer Shinzō Fukuhara spent six months living in Paris in 1913 after studying at Columbia University in New York. Ikko Narahara, one of the founders of Vivo, also lived in both Paris (1962–5) and New York (1970–74). Yasuhiro Ishimoto was truly bicultural: he was born in the United States, spent his childhood in Japan, attended Northwestern University in Chicago and later studied photography with Harry Callahan and Aaron Siskind at the Chicago Institute of Design before settling back in Japan. And in the age of globalization and cheap travel, it has become almost de rigueur for contemporary photographers to study or work outside of Japan. This continued interaction with the West underscores the fact that Japanese photography was truly transnational in scope from its inception.

Another distinctive characteristic of Japanese photography is the significant role played by groups. This trend reflects the importance of group-centred social organization within Japan, where the individual is often said to be subordinate to the group. A number of organized groups have already been mentioned, from the many amateur clubs in the early twentieth century to Vivo and Provoke in the post-war era. Another example of group emphasis is the degree to which photography became a family affair in Japan, often passed down from father to son. Perhaps the best-known example is the Tomishige Studio of Kumamoto in south-west Japan. Studio founder Rihei Tomishige was one of the earliest commercial photographers outside a major city, opening his business in 1870 (see illus. 58). It has subsequently been passed down through four generations. Other examples include Masahisa Fukase, who was of the third generation of his family to take up photography. While family photography businesses may well have been common in other countries, they are a particularly apt manifestation of the Japanese emphasis on the group. Organized groups continue to be important for both professionals and amateurs and photography clubs enjoy a wide following today: trips organized around photographic expeditions are a popular activity for retirees, for example.

Finally, a third key element in Japanese photographic history has been the central role of print publications. As mentioned above, periodicals such as *Kōga*, *Provoke* and *NIPPON* provided an important forum for helping to spread the latest artistic styles, and Japanese photo-books of the 1960s and '70s gained immediate attention for their innovative subjects and approaches. But the photographic book actually dates back to the earliest years of Japanese photography, originating with the two-volume set *Views of Japan* issued by Felice Beato around 1869. Beato developed a thriving business selling standard issue souvenir albums with pre-selected photos tipped in (though images could be custom-ordered as well).[27] From 1889 Kazuma Ogawa ran a prolific publishing business, issuing numerous illustrated books on topics ranging from geisha to flowers to the Russo–Japanese War (1904–5). These often had a major appeal outside of Japan: the Western world was still hungry for information about the newly opened country and such books provided

attractively packaged and compelling visual data. For much of the twentieth century prior to the expansion of museums and galleries in the 1980s, photo-magazines and books provided the main venue for the display of photography. Even in an age of increased institutional attention, publications remain a vital format. A wide variety of camera and photography magazines aimed at both professionals and amateurs continue to be published in Japan today, and Japanese photo-books made by a plethora of contemporary photographers are now hot commodities around the world.

The following chapters proceed to explore three significant themes in the history of photography in Japan. Chapter One, 'Representation and Identity', examines the many ways in which photographers have expressed conceptions of individual, cultural and national identity. Chapter Two, 'Visions of War', traces a century of war photography, from the Bombardments of Shimonoseki in 1864 to the Vietnam War. Chapter Three, 'Picturing the City', considers the depiction of city life over the past 150 years. Often these themes are inextricably intertwined. Since most Japanese people now live in an urban environment, issues of city life are in many ways linked to those of identity, while the Japanese cityscape of the last 50 years is a direct result of the widespread physical damage stemming from the Second World War. Some of the photos included in this text are drawn from the most iconic imagery of the twentieth century. Other photographers and images may be less familiar. It is my hope that new light may be shed on both new and old by considering them as part of these broader themes.

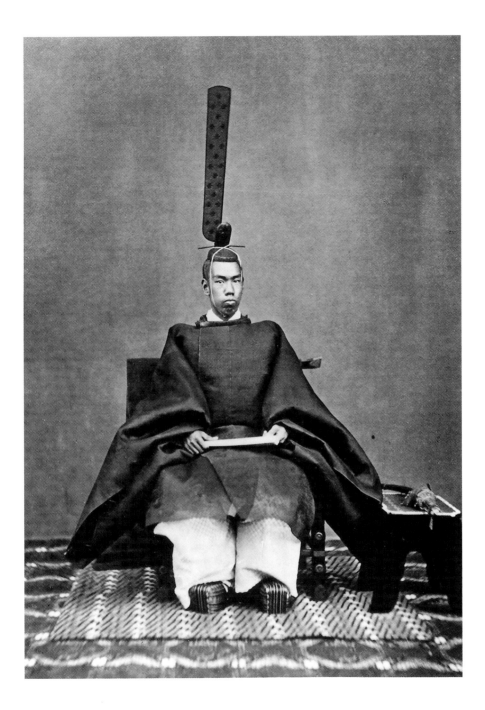

one

Representation and Identity

In 1872, Kuichi Uchida made the first official photograph of the Meiji emperor (illus. 18). The image was taken at the behest of members of the Iwakura Mission, the first diplomatic expedition abroad of the Meiji era. Mission leaders requested a portrait of the emperor to exchange with foreign heads of state as was the custom in Europe. Uchida's photograph showed the emperor wearing traditional court dress, including an impractically tall cap, and seated on a traditional low throne. But government officials soon determined that this portrait conveyed the wrong impression. They feared that it cemented the emperor as the symbol of a feudal, backward country just as Japan was trying to prove to the world that it was anything but that. The photograph was deemed unsuitable, and Uchida was commissioned to produce a second image the following year. The revised 1873 portrait instead showed an updated version of the Japanese head of state (illus. 19). His traditional topknot and centuries-old clothing have disappeared. Seated on a Western-style chair, he now sports a short, modern haircut and a Prussian-inspired military uniform with tailored trousers and an ornately braided jacket. This later portrait was thought to promote a much more suitably up-to-date depiction, and it gained wide circulation both at home and abroad in the 1870s.[1]

These two portraits are intricately connected to early Meiji history for several reasons. Prior to the official beginning of the Meiji period in 1868, the Tokugawa shogunate had effectively ruled Japan for centuries. Although the shogun, in theory, served at the request of the emperor, in practice emperors were mere figureheads who remained cloistered in

18 Kuichi Uchida, *Portrait of the Meiji Emperor*, 1872, albumen print.

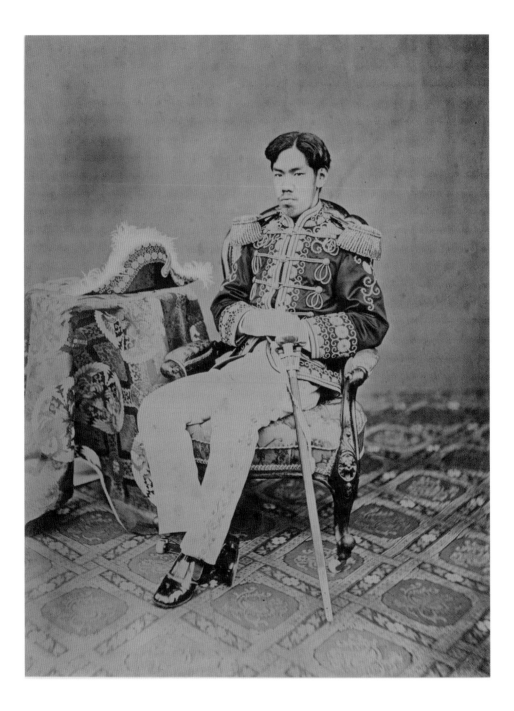

the imperial compounds in Kyoto. When the shogunate was finally overthrown in 1867 by a pro-imperial faction of samurai and courtiers, the emperor was restored as the official head of state. The powerful new oligarchy surrounding the emperor now deliberately positioned him as a very visible symbol of and focus for the nation, parading him in front of the citizens in a series of imperial progresses and promoting his image throughout the country.[2] This was a stark contrast to the previous centuries in which emperors had been hidden from view, their portraits rarely made and virtually never seen. As the Meiji government embarked on an ambitious project of rapid modernization and Westernization, the emperor was used domestically to help visualize a new, modern nation.

The Japanese government commissioning the portrait had an agenda for its foreign audience as well. The trade agreements Japan had negotiated with the major European powers during the 1850s ended up being highly favourable to the Western nations involved (the United States, Great Britain, the Netherlands, Russia and France). They included most-favoured nation status for the Western powers that dictated that rights given to one country would automatically be extended to the others, extraterritoriality for all foreign nationals resident in Japan, and fixed customs duties that prevented the Japanese from controlling foreign trade and protecting their own interests. A key aspect of the Meiji government's agenda to achieve parity with the West was to renegotiate the unequal treaties to their own benefit, and to do so they needed to establish Japan as a civilized, modern country in the eyes of the West. The 1873 photograph of the emperor was an important symbol intended to help convey that message in the early years of the Meiji period.

Uchida's pair of portraits thus form one of the most important examples of the use of photography in the Meiji period. The photos were made with explicit political undertones, as they were very clearly intended to convey the essence of national identity and to shape global opinions. They established the emperor as a symbol of the state, a role that was crucial in helping Japan define itself as a modern nation both at home and abroad. They captured his swift visual transformation from ancient monarch to modern leader, underscoring the speed with which Japan would accomplish the shift from feudal to modernized nation. And

19 Kuichi Uchida, *Portrait of the Meiji Emperor*, 1873, albumen print.

they demonstrated the savvy manner in which the government set out to use photography as a tool directly tied to the national agenda, establishing clear links between photography and the expression of national identity. The degree to which much early photography was connected to issues of national identity (whether implicit or explicit) is striking, but ultimately unsurprising given the strongly progressive and nationalistic programme pursued by the government in its push to achieve parity with the West. Indeed in many ways much nineteenth-century photography has some connection to the broad agenda of nation building. Following the clear precedent set by Uchida's second portrait, photography would repeatedly be used as a means to explore and mediate notions of identity – national, cultural, individual – within Japan.

Ironically, the photographs of nineteenth-century Japan that are most familiar to Western audiences directly undermine the message intended by the 1873 imperial portrait. One category of Japanese photographs played a formative role in shaping ideas about nineteenth-century Japanese identity overseas: Yokohama photographs, or tourist photography. A genre first produced by Felice Beato and other foreign photographers based in the port city of Yokohama and later by the Japanese photographers they had trained, Yokohama photographs were a major cultural export through the turn of the century.[3] These photographs were sold by the thousands to the globetrotting Western tourists who visited Japan beginning in the late 1860s as souvenirs of their experiences; they were eventually also sold in shops in Europe and the United States to armchair travellers. Yokohama photographs were an important source of visual information about a country most Westerners had little knowledge of, but since they were made for a foreign audience, the subject-matter tended to confirm Western stereotypes of Japan's exotic nature. Such albums generally were broken down into two broad categories of imagery. Scenic views depicted sites of historical interest and natural beauty, purposely avoiding the new Western-style buildings, railroads and other technological advancements that indicated the changes taking place in nineteenth-century Japan (illus. 21). 'Costumes and Customs' focused on people engaged in traditional activities and wearing traditional clothing, conveniently omitting depictions of the latest Western fashions (illus. 20). The sense

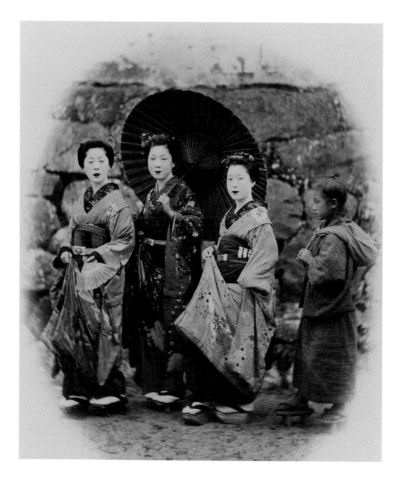

of Japanese identity cultivated by these photographs was of a timeless, exotic land; yet paradoxically, Japan was rapidly changing into an industrialized nation, an image directly at odds with the vision conveyed in the photographs.

Many Yokohama photographs are visually pleasing, artfully arranged compositions whose aesthetic appeal is heightened by the delicate hand-painting that rendered them in colour (a tradition also initiated by Beato). The ultimate effect was to create a fantasy of a simple, primitive Japan that appealed to foreign tastes. This was an identity that fitted the concept of 'salvage' tourism – the idea that it was the obligation of the Western

colonial powers to document and record traditional cultures before they slipped away (although Japan was never actually colonized). What is particularly striking about the genre is how exceptionally enduring this impression of Japan has been well into the twentieth century. Since they were exported, countless such images can be found in museum collections in the West (and no doubt languish forgotten in many an attic). Until quite recently, museum and gallery shows have suggested that such images represent accurate portrayals of nineteenth-century Japan, recalling lingering stereotypes that have persisted for more than 100 years.[4] The images the Japanese themselves were purchasing at this time look significantly different; indeed throughout the nineteenth century photographs were often used deliberately by the Japanese to express ideas of 'modern' identity diametrically opposed to the message of the Yokohama photographs.

While the emperor's portrait was meant to convey the essence of modern Japanese identity on a national and explicitly political level, a related phenomenon played itself out in the local portrait studios that were rapidly expanding throughout Japanese cities. Since portraiture was not widespread prior to the introduction of the camera, the ability to have one's likeness captured was directly linked to the modernization of the early Meiji period. Ordinary citizens increasingly rushed to sit before the camera, eager to have their images made with the latest Western technology. In contrast to the images of Beato and his followers, formal studio photography of the nineteenth century often featured trendy Westernized settings and props. Commercial photographers posed their subjects on Western-style chairs upholstered with Gobelin tapestries. The sitters sometimes showed off the latest Western fashions and often held foreign novelty items such as umbrellas, while painted backdrops conjured up visions of the exotic West. Some photographers even kept Western clothing on hand to lend to sitters who did not have any of their own. Even when pictured in Japanese dress, however, the very act of having a portrait taken would have signalled a claim to modern identity for those pictured, as they participated in this latest imported social practice.

Early portraits clearly reflected class identity as well. Among the first to be photographed, even before the Meiji Restoration, were samurai,

who were members of the cultural elite. The costs for photography at the time were prohibitive, limiting availability, and so having a portrait taken in the 1860s would have required cash and/or connections to the still-rarefied field. (It is noteworthy that the studios that opened in the 1860s primarily marketed their images to foreigners, as they were the audience most able to afford them.) Portrait photography became increasingly widespread from the 1870s on. More than 100 portrait studios operated in Tokyo by 1877, for example, though photography was slower to spread in more rural areas.[5] Even once studios became more common, it is likely that for most people having a portrait taken

21 Felice Beato, *Tokkaido, c.* 1867, hand-coloured albumen print.

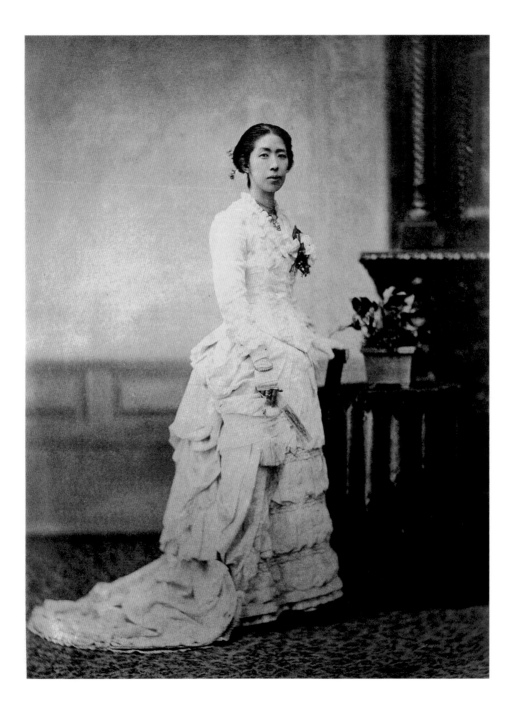

was a rare event, at least until the introduction of dry-plate technology in the 1880s lowered costs and increased accessibility throughout the country. For much of the nineteenth century, then, having a portrait taken would have been a status-enhancing act for the average person, a marker that the patrons were participating in the latest fad connected to modernization. In these early portraits, clothing often indicates social status, particularly for women. While men throughout the country rapidly adopted foreign dress from the 1870s on, Western styles for women never made much headway outside of Tokyo, and even within Tokyo only wealthier people could afford the elaborate tailoring required. Many photos of Tokyo women showed them in elaborate Western gowns, marking them as members of the upper class and thus confirming both geographic and social identity (illus. 22).

The tradition of photographs produced for foreign trade continued in the late nineteenth and early twentieth century with Kazuma Ogawa. Ogawa's thriving publishing business produced a variety of illustrated books aimed at the Western market. These too focused on the two major categories initiated by the Yokohama photography genre, scenic views and images of traditional Japanese people and activities. Representative titles included *The Charming Views in the 'Land of the Rising Sun'* (1904), *Sights and Scenes on the Tōkaidō* (1892) and *Types of Japan: Celebrated Geysha* [sic] *of Tokyo* (1892). Historical costumes were a popular subject. Ogawa issued several different books on this theme, and often the books included imaginative recreations of ancient Japan. In *Japanese Costume Before the Restoration* (1895), for example, actors appear in clothing from previous eras and also engage in historical activities, such as the two actors posed as if sculpting an eighth-century Buddhist guardian figure in 'Buddhist sculptors' from *Japanese Costume Before the Restoration* (1895, illus. 23). These books, too, actively mediated the image of Japan received by the West, generally reinforcing the stereotypes and narratives conveyed by the Yokohama photography genre.

Ogawa produced books for the Japanese market as well, and was often commissioned for government-sponsored projects. In 1888, he toured the Kansai area, home to many important ancient temples, to photograph as part of an official survey of national treasures. He was

22 Unknown photographer, *Kaneko Shibusawa*, late 19th century, albumen print.

45

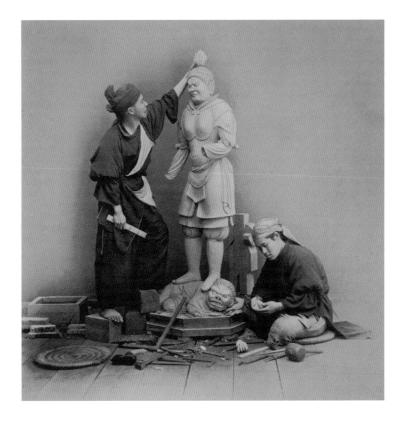

not the first photographer to do so – Matsusaburō Yokoyama had participated in a survey of national treasures as early as 1872 – but Ogawa's images attracted much greater attention from the general public, thanks to the much wider circulation created by improved printing technology. One of Ogawa's earliest projects at his newly established publishing business was to issue Japan's first art magazine, *Kokka* (National Essence), in 1889. *Kokka* focused on traditional Japanese art and featured Ogawa's images of Japanese Buddhist sculpture taken for the survey of cultural assets conducted the previous year.[6] As the title suggests, *Kokka* was invested in recording and promoting the nation's treasures. This magazine captured the zeitgeist of the late nineteenth century, when an interest in preserving traditional Japanese culture developed in response to fears that the country's quick modernization

had come at a significant cost to native ideas. Ogawa was joined in this endeavour by Ernest Fenollosa, an American professor at Tokyo Imperial University, and Tenshin Okakura, a scholar and writer, both of whom were vocal proponents of traditional Japanese art.[7] The same photographs of historical temples that might be viewed as quaint foreign exotica in an exported picture book thus became emblems of national pride when published in *Kokka*.

Another key nationalistic use of photography in the Meiji period was as a tool to help establish and visualize the physical boundaries of the Japanese state. Kenzō Tamoto received one important early commission to record land development in the north. Tamoto had established a studio in 1869 in the city of Hakodate, Hokkaido, the northernmost of Japan's four main islands and an area that had just been brought under official Japanese jurisdiction that year. When the Hokkaido Settlement Office opened in 1871, Tamoto was the logical choice for its first major project. Like many Meiji programmes, this was modelled on a foreign example: it paralleled the similar use of photography to document the expansion of the American West. Tamoto travelled around Hokkaido, producing more than 150 images of the construction of new buildings and roads. The photographs were used in reports sent back to the central government in Tokyo, and they were also distributed to regional government offices throughout the country. After the completion of this initial project, Tamoto continued to record Hokkaido development over the remainder of his career, expanding from photographing buildings and roads to recording railroad construction, agriculture, mining and other industrial growth, and even the first telegraph wire connecting Hakodate and Sapporo (illus. 24).[8] Such photographs helped to substantiate Japanese rights to the land under the threat of Russian encroachment. They also confirmed the benefits to the nation of 'civilizing' the northern frontier.

Photographer Shinji Matsuzaki joined another government-sanctioned project, an official expedition to the Ogasawara Islands in 1875–6. This group of islands, located some 700 miles south of Tokyo, had been settled by non-Japanese (Europeans, Americans and Polynesians) just four decades earlier. The Japanese were interested in bringing this

territory under their control, but the fact that it had Western settlers provided an interesting conundrum. According to David Odo, correspondence from Matsuzaki reveals a condescending reaction towards the locals, who would have to be viewed as inferior to the Japanese in order to justify Japanese colonial rule. However, this position was in direct conflict with the standard Japanese attitude towards the West at the time, which was admiration. Interestingly, the photographs Matsuzaki submitted to the government tended to minimize the foreign settler presence. One such photograph documented a memorial erected by the Japanese in 1862, a stone that was inscribed with Japanese text speaking of 'historical connections'. The image shows the site in

24 Kenzō Tamoto, attrib., *View of Hakodate Customs House, Hokkaido,* c. 1870s, albumen print.

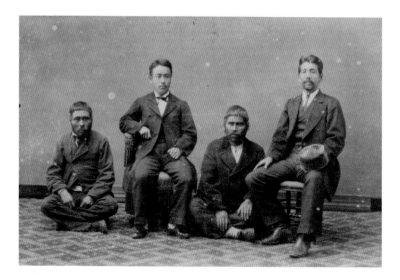

an untended state that suggests it is significantly older, establishing the appearance of historical links that, in turn, helped to provide the authority to annex the islands.[9]

The process of photographing the expanding national borders was not restricted to architectural or landscape photography but often focused on human subjects as well. Photographs of the Ainu, an indigenous group native to Hokkaido, played a prominent role in shaping both Japanese national and modern identity, for instance. The Meiji government's northern expansion meant that the Ainu suffered loss of their domain and traditional lifestyles. The Ainu were required to give up their land, and the government mandated that they assimilate into Japanese culture, forcing them to abandon their language, clothing and traditional customs such as facial tattooing. Photographs recorded the Ainu, and even if they appeared to be assimilated, images still often managed to emphasize their 'primitive' nature. Indeed, visual culture deliberately highlighted the differences between the Ainu and the Japanese in order to reinforce the cultured and civilized credentials of the latter. A studio portrait by Kenzō Tamoto is a typical example (illus. 25). In this portrait of four men, two Japanese and two Ainu are all shown wearing Western dress, a well-established marker of modernity. But while the two Japanese wear crisply

tailored suits, those of the Ainu men appear ill fitting. Additionally, the two Japanese are seated on chairs, while the Ainu remain on the floor. Even though all four wear the uniform of the modern man, differences in their seating positions and relative heights visually reinforced the difference between the civilized Japanese and the 'lesser' barbarian Ainu, confirming the superiority of the Japanese.[10] Significantly, the Hokkaido Settlement Office submitted photographs of both Hokkaido development and the Ainu for display at the Vienna World Exposition of 1873 to help document and support Japan's colonialist credentials.[11]

As Japan began to increase its colonization efforts, expanding its geographic territory as a direct consequence of military success, Japanese photographers visited other Asian countries and photographed other native peoples. Ryūzō Torii's turn-of-the-century ethnographic images of Taiwanese aborigines testify to the importance of racial and cultural identity in the context of this new Japanese imperialism, and underscore the significance of photographs in helping to construct the imperialist dialogue (illus. 26, 27). As Ka F. Wong has described, Torii was an anthropologist who was vying to make a name for himself just as Western-style anthropology started to make waves in Japan. While established Japanese anthropologists worked primarily with textual sources, Torii helped to solidify the importance of fieldwork as a fundamental element of anthropological inquiry. As an inherent part of fieldwork, photographic evidence formed a major component of his work. He made numerous trips to Taiwan soon after it was annexed in the aftermath of the Sino–Japanese war and photographed various ethnic tribes, using the clinical, head-on view that was by then a standard visual formula for ethnographic photography. The resulting images helped to define the parameters of Japanese modern national identity, since they documented another culture that provided a primitive 'Other' counterpoint to the modern Japanese. Torii's photographs of ethnic Chinese followed the same type of pattern established in Tamoto's Ainu images, confirming Japanese domination over the 'Other' through visual means. His photographs, moreover, illuminate the government-sanctioned ethos that positioned the Japanese as superior to other Asian cultures, and thus clearly helped to shape a Japanese colonialist identity.[12]

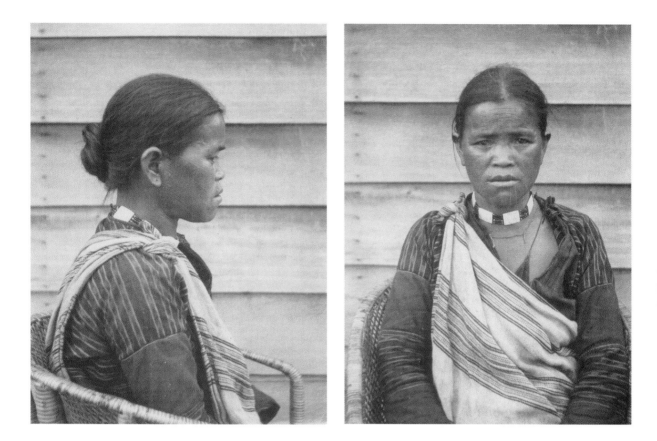

26–7 Ryūzō Torii, *Portrait of Taiwanese Aborigine*, c. 1900, albumen print.

Back on the home front, photographs were being used in a number of ways both to create and to reinforce a strong sense of Japanese national identity in the 1890s and early 1900s. Often these nationalistic purposes were intimately bound up with new ways of using the medium. The last decade of the nineteenth century saw printing techniques advance to the point where it became feasible and much more cost-effective to publish photographs in the media. Two examples stand out as particularly compelling instances of the intersection of individual portraits and print media being used to further patriotism and reinforce national identity. Naoyuki Kinoshita has written of the connections between portraits of soldiers and the national agenda at the turn of the century, a period that spans two crucial wars (the Sino–Japanese War of 1894–5, and the

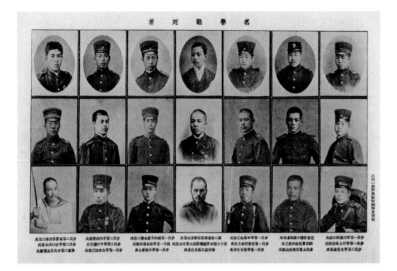

Russo–Japanese War in 1904–5, discussed in the next chapter). During the Sino–Japanese War periodicals, including the journal *Nisshin sensō jikki* (Record of the Sino-Japanese War), published special supplements of portrait photographs of the war dead, including both officers and lesser-ranked soldiers. Kinoshita argues that such publications expanded the role of portrait photography by helping to transform portraits of the war dead from private mementos to public images. He also suggests that the decision to print portraits was related to sales, as universal conscription was implemented in the 1890s, and the families of conscripted soldiers would probably have been a primary audience for war-related magazines.[13] As symbolic images of the war, portraits of the war dead represented both individual loss and Japanese military success. Adopting private images to serve as symbols of national pride played a crucial role in helping to shape public opinion and thus helped to define the national agenda.

One public instance of portrait photography being used to help promote nationalism was the printed portraits of deceased soldiers. A parallel development can be seen in the newly public uses of portrait photographs of women. In 1908 portrait photographs of young women were published in the *Jiji shimpō* (Current Events or The Times)

newspaper as part of a national contest to find the most beautiful woman in Japan (illus. 29). The contest was initiated by the *Chicago Tribune,* who invited newspapers around the world to submit photographs for an international beauty competition. Flushed with confidence and national pride after their Russo–Japanese War victory, the Japanese eagerly jumped into the fray. *Jiji shimpō* framed the competition in frankly nationalistic terms, asking for contestants willing to engage in a beauty battle that would help cement Japan's reputation as a player on the world stage. The initial contest announcement read:

> If there is anyone among the troops of virtuous girls of victorious Japan who wishes to volunteer to engage in this battle, quickly name yourself . . . Now, when we are tired of war with weapons, a war with women's beauty is a novel and very interesting idea, and our company, on behalf of millions of beauties all over the nation, accepted the declaration of war.[14]

The language used deliberately referred to Japan's recent military successes and extended the 'battlefields' to this new demographic, enabling young 'beauties' to demonstrate the nation's pride by defeating the international competition.[15] For both the war dead and the young 'beauties', the photograph was used in combination with new print technologies to mark national pride and identity.

Much of the photography discussed thus far served either to create or reinforce the official government agenda. Images by Uchida, Torii and Tamoto deliberately promoted narratives of national progress, while popular portrait photography helped to confirm that modernization had indeed reached all levels of society. The role of these images in identity construction was to help visualize new cultural norms and expectations, but there are compelling examples of photography being used to document more transgressive explorations of personal identity in Japan. Portraits of Charles Longfellow, the son of the American poet Henry Wadsworth Longfellow, did just that.

As Christine Guth has demonstrated, Longfellow deliberately used photography as an 'instrument of self-fashioning' as he negotiated his

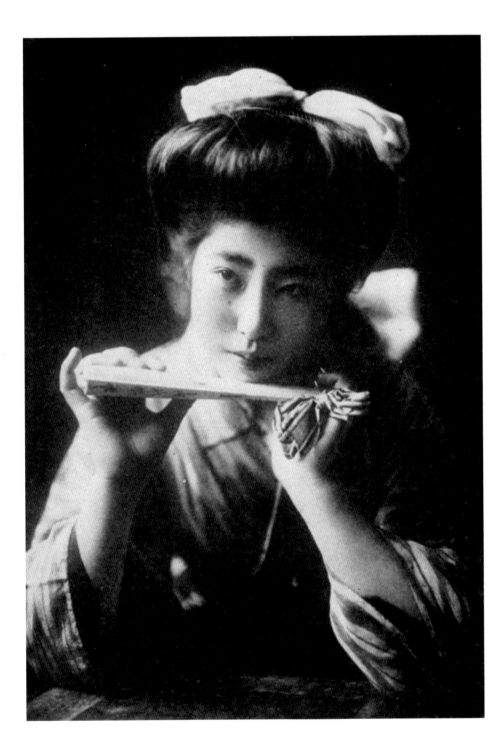

own sense of identity in a cross-cultural context.[16] Seeking to escape the confines of familial and cultural expectations back in the United States, Longfellow 'went native' by immersing himself in a foreign culture (Japan), adopting local dress, then repeatedly having himself photographed; additionally he underwent traditional tattooing. Longfellow was not satisfied with merely dressing in Japanese casual wear and documenting himself lounging with Japanese friends. Instead he actively performed for the camera, appropriating various Japanese personas as he played dress up. He had himself photographed wearing samurai dress and swords in the studio of the well-known photographer Hikoma Ueno. While this might have been a standard service offered by Ueno to the many foreigners who came to his Nagasaki business, other Longfellow portraits are more extreme. They show him mimicking the pose and dress of a Kabuki actor (illus. 31), or dressed in traditional carpenter's clothes and depicted along with a similarly costumed geisha who is engaged in a bit of role-playing and gender-bending herself. Such photographs testify to the power of the medium as a means of self-expression from its earliest years.[17]

The importance of group culture in Japanese society provides another fruitful avenue linking issues of identity with early photography. Portrait photography throughout the nineteenth century often focused on groups, with subjects ranging from families to students to those in various professions, including politicians, lawyers and soldiers (illus. 30). Commemorative images were a standard element of many events from the earliest years of photography: the opening of a new modern school or government building would be celebrated with a group photograph taken on site. Images such as these helped to document and reinforce various manifestations of group identity. This tradition has remained popular: anyone who has ever observed a group of Japanese tourists either in Japan or abroad is familiar with the spectacle of big groups posing for photographs at famous tourist sites, and taking a *ki'nen shashin* (commemorative photograph) is standard practice at all kinds of group functions today.

One of the distinctive characteristics of art photography in late nineteenth- and early twentieth-century Japan was its group nature. As previously mentioned, the movement tended to focus on photography

29 Kiyoshi Esaki, attrib., Beauty contest winner Hiroko Suehiro from *Nihon bijinchō* (Book of Japanese Beauties) (1908).

clubs formed of like-minded amateurs who gathered to share their hobby and to exhibit together. These clubs also published private editions of photographic books, similar to the long-established historical trend of poetry clubs issuing limited-edition private woodblock prints. Such clubs provided social interaction as they helped to cultivate group identity. Some of the most innovative avant-garde photography came out of this context. For instance, Kiyoshi Koishi joined the Naniwa Photography Club, one of the best-known clubs, in 1928. (It had been founded in Osaka by Kichinosuke Ishii and Shozaburo Kuwata in 1904.) He exhibited a series of ten images for the club's twenty-first annual exhibition in 1932; the club then published this seminal work, *Shoka shinkei* (Early Summer Nerves), the next year (illus. 32). *Shoka shinkei* included photograms, poetry and photomontage inspired by the New Photography movement, bound between two zinc plates. It was just one example of the group dynamic helping to further cutting-edge artistic styles.

Photo clubs and salons formed an important part of the artistic landscape for the Japanese outside Japan as well. Japanese photographers in the United States (particularly on the West coast) also tended to form

30 Kuichi Uchida, *Faculty and Students of the Naval Academy, Tsukiji, Tokyo*, 1873, albumen print.

31 Hikoma Ueno, *Charles Longfellow as an Actor*, 1871–3, albumen *carte-de-visite*.

clubs, which provided a means of maintaining a cohesive sense of cultural identity while living in a foreign country. These clubs curated group exhibitions, much as their brethren back in Japan, and members shared their interests in Pictorialist-style alternative printing processes and nature-based subject-matter. An exemplary image is *Fantasy* (1930) by Harry K. Shigeta, which depicts delicate tree limbs floating down from the upper right-hand corner in front of a moon (illus. 33). At 34 x 18.3 cm, the image resembles a miniaturized traditional hanging scroll in its

32 Kiyoshi Koishi, 'Early Summer Woman', photo-montage from the photo-book *Shoka Shinkei* (Early Summer Nerves), 1933.

33 Harry K. Shigeta, *Fantasy*, c. 1930, bromide print.

proportions rather than a standard negative size. Moreover the printing technique completely mimics traditional ink painting. Though no text is found on the print aside from the artist's name (in Roman letters rather than Japanese), the format, tonal qualities and presence of a seal lead one to immediately associate it with traditional landscape paintings, which often incorporated poetry. The aesthetic similarities between this approach and traditional Japanese painting may have held a special emotional resonance to these expatriate artists.[18]

Examples of photography being used to express cultural and national identity remain prominent throughout the first half of the twentieth century. Even within artistic photography, a genre seemingly more focused on aesthetics than on political connotations, links can be drawn to issues of nationalism. Among early twentieth-century art photographers, one of the best known and most influential was Shinzō Fukuhara, whose family headed the Shiseidō cosmetic empire. Fukuhara's work tended to feature soft-focus effects, although he and his brother Rosō both advocated moving away from the Pictorialist emphasis on manipulated printing processes towards experimenting with light and shadow and choosing unusual compositions. Both Fukuhara brothers were part of a circle of artists who strove to develop a distinctly Japanese form of art photography. Shinzō advocated the idea that the best exposures should be akin to haiku poetry, and thus should capture the essence of a scene or moment in a minimalist yet emotionally powerful manner (a sentiment that recalls Henri Cartier-Bresson's 'decisive moment'). The Fukuhara brothers' interest echoed the similar late nineteenth-century movement promoted by Tenshin Okakura and Ernest Fenollosa to develop a uniquely Japanese style of modern painting. In both cases, the desire for a specifically 'Japanese' style was a response to concerns that Japanese cultural identity had been compromised by artists slavishly copying Western precedents.[19] Despite this interest, much of Fukuhara's work depicted foreign subjects, including Paris, Hangchou, China and Hawaii (illus. 34).[20]

Yasuzō Nojima's artistic nudes also intersect with issues of Japanese cultural identity, in addition to drawing on both class and gender. Nojima produced a series of nude female figures from around 1915 to the early

35 Yasuzō Nojima, title unknown, 1931, bromoil print.

34 Shinzō Fukuhara, *Beautiful West Lake*, 1931, gelatin silver print.

1930s that blended the elaborate printing processes favoured by Pictorialist artists with a more direct approach to composition and subject-matter. The models used in these images did not fit the typical standards of Westernized ideal beauty then popular in Japan: the women had thicker figures and appeared to be lower class. Philip Charrier has suggested that these photographs appropriated a Western Orientalist fantasy of the submissive, exotic, primitive, female 'Other' but translated it into class, rather than racial, difference. In Nojima's work, he argues, the Japanese rural/peasant type becomes the 'Other' and the Orientalist gaze is assumed by the upper-class Japanese male artist, thus subverting

the paradigm from an East-West one into a class-based one.[21] Examples of similar female types used to suggest the idea of a primitive utopia can be found in other visual arts of the period, notably the paintings of Bakusen Tsuchida.[22] Beyond issues of class, the emphasis on images of a 'pure' Japanese womanhood was tied to a broader trend of equating the feminine with Japanese aesthetics, as opposed to the masculine West. Woman symbolized the nation, an ongoing manifestation of appropriating the feminine as national emblem that had begun in the Meiji period.

Connections between photography and nationalism continued in the context of Japanese imperialism of the 1930s and '40s. Photography was used as a tool both domestically and abroad to help shape national perceptions and to proclaim Japanese patriotism during the Second World War (further explored in the next chapter). The pattern of organized groups and publications playing a crucial role in furthering photographic expression continued but, starting in the 1930s, the groups were generally affiliated with the government. In 1940, the government began to censor photography magazines and independent groups, and from 1941–5, photographers had to produce work that was acceptable to the authorities. Much photography from this period is therefore explicitly propagandistic.

There were a number of different venues in which photographers could publish and be active during this period. Illustrated journals and books issued within Japan included *Hōdō shashin* (Photojournalism) and *Shashin shūhō* (Photography Weekly), published by the Cabinet Information Bureau and featuring work by Ihee Kimura and Kiyoshi Koishi, among others. Groups too took up the call of patriotism. The *Kōa shashin hōkokukai* (Asian Development Photography Patriotic Society), in existence from 1940–45, promoted 'patriotic photography' and sent family photographs to enlisted men to help encourage them in their war efforts, while members of the *Manshū shashin sakka kyōkai* (Manchuria Photographic Artists Association) published their pictures in *Manshū Graph* (Pictorial Manchuria), another propaganda magazine.[23] Patriotic photographic displays at home included exhibitions of war-related imagery at department store galleries, such as 'The Great Photography Exhibition to Raise the Spirit of Annihilation' in February

36 Asahi Shimbun, *'Uchiteshi yamamu'* (Keep up the Fight), 1943, photo-mural displayed on the Japan Theatre building in Tokyo.

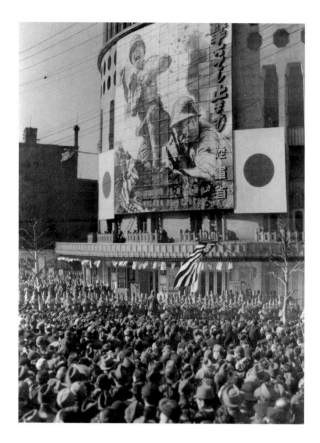

1944. And the monumental (nearly 1,097 square metres) photo-mural featuring photographs by Shigene Kanemura that hung outside a Tokyo theatre in 1943 to mark the *uchiteshi yamamu* (Keep up the Fight) campaign emphasized Japanese military might through its oversized visual rhetoric.[24]

Some of the most memorable propagandistic photography was produced for foreign audiences. The *Kokusai bunka shinkōkai* (Society for the Promotion of International Culture) supported the publication of English-language pictorial works aimed at Westerners, produced under the auspices of the Foreign Ministry. *NIPPON* was one of the best-known journals. Designed by Nippon Kōbō (The Nippon Studio), *NIPPON* showcased photography by editor Yōnosuke Natori, Masao Horino, Ken Domon

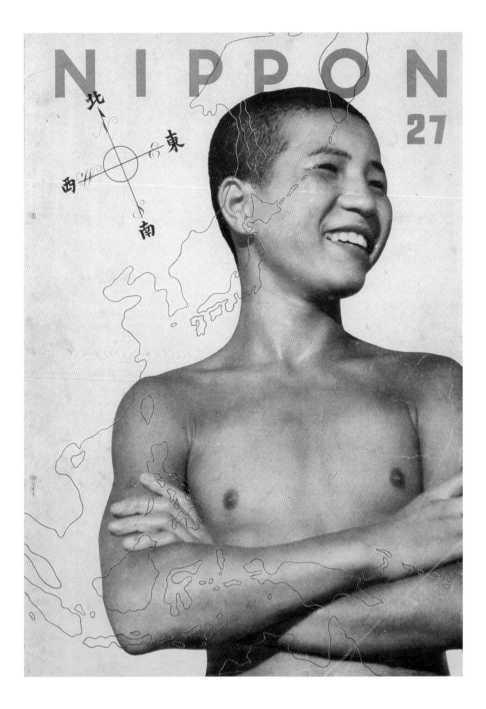

37 Nippon Kōbō, cover of *NIPPON* issue on
Manchuria (1941).

and Yoshio Watanabe. It was published quarterly from 1934–44, with a
special edition book issued in 1937. *NIPPON*'s strong graphic layout and
dynamic photography made it one of the most striking Japanese photo-
graphic publications. It featured illustrated spreads that tended to promote
Japan and its expansionist tendencies as a blend of the best aspects of
both traditional culture and modern progress. Manchuria, for example,
is presented through a combination of text and image as a vibrant place
where the benevolent Japanese have peacefully integrated and successfully
built a modern utopia (illus. 37).[25] This approach attempted to help
legitimize Japanese imperialism and was intended to mitigate global
concerns about increasing Japanese aggression in Asia. The book from
1937, featuring a series of two-page photomontages bound in a trad-
itional accordion-style, is a stunning work of art.

　　Tōhōsha (Far East Company), another wartime propagandistic photo
organization active from 1941–5, produced an equally visually powerful
magazine, *Front* (see illus. 67, 68). It too was intended for foreign audi-
ences: it was published in as many as sixteen different languages, and it
circulated among the Greater East Asia Co-Prosperity Sphere (areas of Asia
under Japanese control including Manchuria, China and Southeast Asia).
Issues were devoted to special topics, such as the navy and the air force.

38 Nippon Kōbō, photomontage from
NIPPON (1937).

Like *NIPPON,* it drew on photojournalism and also combined images in striking photomontages. In addition it was printed in full colour gravure.[26] Notably, though *NIPPON* and *Front* represent the height of Japanese creativity in an imperialist context, both publications were partly based on foreign models. *NIPPON* was inspired by the German graphic magazines Yōnosuke Natori had encountered while working in Berlin, while *Front* took its cue from the Russian propaganda magazine *USSR in Construction.*

In the aftermath of the war, photography continued to be used to shape perceptions of the nation. Photographs were employed immediately following Japan's official surrender in September 1945 to help the Japanese reconfigure their world view. Japanese militarism had been tied to the concept of State Shintōism, a modern and nationalistic variation of Japan's native animistic religion. State Shintōism promoted a conception of Emperor Hirohito as a god, a deified father figure at the head of the Japanese nation who garnered undying loyalty. Members of the Imperial Forces believed that in serving the country they were directly serving this emperor-god, which had contributed to the fanaticism with which they approached battle. Therefore, weakening the emperor's image was an important element in the Allied Forces' agenda of transforming Japan from an imperialist power into a democratic nation. But here the propagandistic use of imagery was directed by the occupying American forces rather than the Japanese.

A key image of Emperor Hirohito and General Douglas MacArthur taken in September 1945 is surely one of the most iconic images in modern history (illus. 39). Although the Japanese had surrendered, the Americans had a vested interest in turning the emperor into an unthreatening figure. This single image, which the historian Harry Harootunian has described as a 'bourgeois wedding' photo, went a long way towards accomplishing that goal.[27] The image shows Hirohito dressed in formal civilian morning dress, dwarfed by MacArthur, a full head taller, wearing an informal military uniform. Moreover, MacArthur's rather casual hip-slung pose, with his arms crooked behind him, provides a significant contrast to Hirohito's stiff posture, emphasizing the American's superiority both physically and symbolically. The circumstances under which the photo was taken further humiliated the emperor. Rather than

39 US Army Signal Corps, *General MacArthur and Emperor Hirohito*, 27 September 1945.

going to the Imperial Palace, MacArthur had forced Hirohito to come to General Headquarters and then left him to wait.

Japanese authorities immediately recognized that the image emasculated the emperor, and ordered it banned. When the photo did not appear in the next day's news stories, MacArthur's office complained to the Japanese Foreign Ministry. The following day, the major news-papers did include the photograph, but they were seized by the Japanese authorities, who claimed that it was 'sacrilegious to the imperial house

and would thus have a detrimental effect on the nation'.[28] Herbert Bix described the source of the conflict:

> The emperor in the photograph was not a living god but a mortal human being beside a much older human to whom he was now subservient. He perfectly exemplified the defeated nation, while MacArthur's relaxed pose projected the confidence that comes from victory. With that one photograph a small first step was taken in displacing the emperor from the center of the Japanese collective identity and freeing the nation from the restrictions of the past.[29]

Bix goes on to describe how only a foreigner (the American photographer, in this case) could have taken the image, as Japanese custom dictated that photos of the emperor could only be taken by those approved by the Imperial Household Ministry and even then only from a significant distance. The American authorities ultimately insisted that it be published, and also ended all of the restrictions on publishing that had been enacted by the Japanese state over the previous decade.[30] With a single photograph, the public understanding of Japan's role in the world was significantly altered.[31]

Yōsuke Yamahata also took photographs that were further intended to remake Japan's imperial identity, helping to transform Hirohito's image from that of a rarefied deity into a more down-to-earth figure.[32] Yamahata was invited by the Imperial Household Agency (though MacArthur likely influenced this activity as well) to photograph Hirohito and his wife at the Imperial Palace. The photographs showed him and Empress Nagako relaxing in the garden, seated at a table and looking over a magazine together. He gestures to the page as if pointing something out, while she looks on demurely. The supposedly casual moment was meant to portray the emperor as an approachable family man. It must be noted that MacArthur wanted to maintain Hirohito as a focus for the country, though more as a benevolent symbol, absolved of responsibility for atrocities committed while he was commander-in-chief of the Japanese Imperial Forces. The images appeared in the United States, in *Life* magazine, to help mitigate lingering negative perceptions about Japanese wartime behaviours.[33]

Other imperial symbols were repositioned through the use of photography as well. Yoshio Watanabe's photographs of Ise Shrine form another instructive example (illus. 40, 41). Ise is a traditional Shintō shrine, one of the most important as it has long historical connections to the Imperial Family and houses the traditional imperial regalia. As a result of this connection, the shrine had become strongly associated with State Shintōism. In a centuries-old sacred ritual, the shrine is rebuilt every twenty years. When it was rebuilt in 1953, Watanabe was granted unprecedented access to the secret inner precinct of the shrine, an area traditionally only accessible to members of the Imperial Family and select designated priests. Watanabe made a series of views of the buildings in the inner compound, including many close-up, cropped shots. As Jonathan Reynolds has argued, the images served several important functions in reconfiguring the image of the shrine and its connection to the national ethos. First, the photographs exposed the secretive inner shrine to all, stripping bare the imperialist mythology by making it visible. Additionally, the strongly Modernist aesthetic of the photographs repositioned the subject as art. By treating the complex as an aesthetic object rather than a rarefied spiritual arena, the images stripped away the mystique of the imperial persona, altering the shrine from a negative symbol of imperialist Japan into a treasured historical-cum-aesthetic object.[34] Through carefully staged and circulated images of the emperor and of Ise, photography thus played a critical role in helping to reshape the national consciousness in the decades following the Second World War.

An interest in documenting activities and symbols of traditional Japan continued over the next several decades. Many photographers turned their attention to folk traditions and rural lifestyles, producing work that is often tinged with nostalgia. This was largely a reaction to the significant social changes of the postwar period. The Allied Occupation from 1945–52 introduced a heavy American influence, while post-war rebuilding helped to bring about dramatic populations shifts. The urban population increased significantly, from approximately 37 per cent of the population in 1950 to nearly two-thirds (65 per cent) just ten years later.[35] A general sense of unease about this rapid transformation was manifested

41 Yoshio Watanabe, *Ise Shrine: The North Facade of the Main Sancturay*, 1953, silver gelatin print.

40 Yoshio Watanabe, *Ise Shrine: The Main Sanctuary Seen from under the Eaves of the West Treasure House*, 1953, gelatin silver print.

in a renewed interest in capturing traditional Japanese culture, part of a national reflection on the meaning of Japanese cultural identity.

Photojournalism, as the dominant style of the 1950s, lent itself readily to narrative documentation of Japan's folk heritage. Hiroshi Hamaya and Hiromi Tsuchida were two prominent photographers working in this idiom. Hamaya photographed varied aspects of rural life in northern Honshu, from festivals to rice planting and other daily activities. An image of two *goze* from Niigata is representative (illus. 43). *Goze* were itinerant blind female musicians, who had historically travelled the countryside performing in order to support themselves. In Hamaya's photo, two women are seen walking with their *shamisen*, a traditional

string instrument, dressed in kimono and *geta*, traditional wooden clogs. The elder of the two has an elaborate old-fashioned hairstyle. Their appearances and activity both captured the spirit of Japanese traditional culture and recalled an ideal of a simpler past. Tsuchida also documented traditional Japanese cultural activities such as religious festivals and leisure activities during the 1970s. His best-known work from this period appears in the book *Zokushin* (Gods of the Earth).[36] And in dramatic contrast to such documentary-style photography, Ikko Narahara also captured traditional symbols of Japan in his 1970 book *Japanesque*, but in psychedelic colour (illus. 44).

The overwhelming trend spanning the first 100 years of Japanese photography and the link between most of the images discussed thus far

43 Hiroshi Hamaya, 'Blind Musicians under Snow Protection', from *Snow Land*, 1956, gelatin silver print.

42 Hiromi Tsuchida, 'Ise, Mie Prefecture', from *Zokushin* (Gods of the Earth), 1972, gelatin silver print.

has been their relationship to national or cultural identity. With the exception of several decades in the early twentieth-century Taishō Democracy in which the concept of a Western-style individualism was emphasized (further explored in chapter Four in relation to urban photography), most of Japan's first modern century was focused on the formation or negotiation of a specifically Japanese identity. In the post-war period photographers have continued to explore issues of identity, though work produced over the last 50 years has shied away from a focus on the nation. In the 1960s and '70s attention shifted towards more individualistic concerns, and the dominant tendency over the last half century has been towards a much more personal exploration of identity. The influence of both Vivo and Provoke were crucial in shaping the style of photographers working in this vein. The more relaxed technical and formal approach of those two collectives was aptly suited to a more intimate kind of photography.

44 Ikko Narahara, 'Japanesque', *IRO #3*, 1968, direct print: published in the photo-book *Japanesque* (1970).

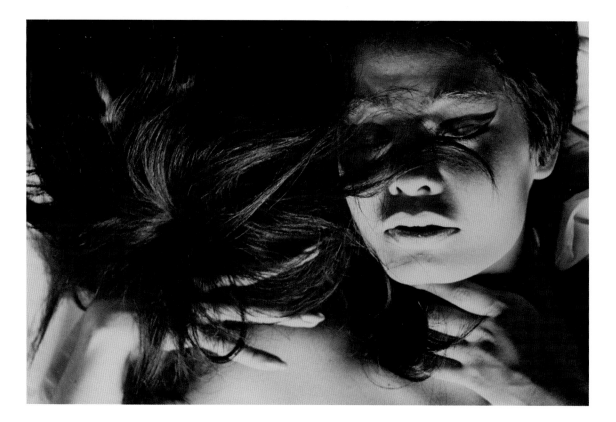

45 Masahisa Fukase, *Yoko*, 1963, gelatin silver print.

Two of the best-known artists to produce such images were Masahisa Fukase and Nobuyoshi Araki. Fukase often focused on his family relationships in his work. He turned his camera on his wife Yoko, a *noh* theatre (a traditional form of theatre that draws on Japanese classical literature and history) actress whom he married in 1964, and she remained his major subject over the next decade, until they divorced in 1976. Fukase published two books, *Yūgi* (1971) and *Yoko* (1978), that both focused on Yoko. In a series of images that challenged the traditional conventions of Japanese portraiture, Fukase portrayed her in strikingly intimate moments – dancing half naked in a field, gazing in a mirror while partially undressed, floating in water. The images are a candid record of the photographer's deepest moments of connection with his beloved, and they reveal the wide range of her emotions.[37] Araki took a similar approach with his wife, also named Yoko, whom he photographed repeatedly from when they first met in 1968 until her death in early 1990. One of the most

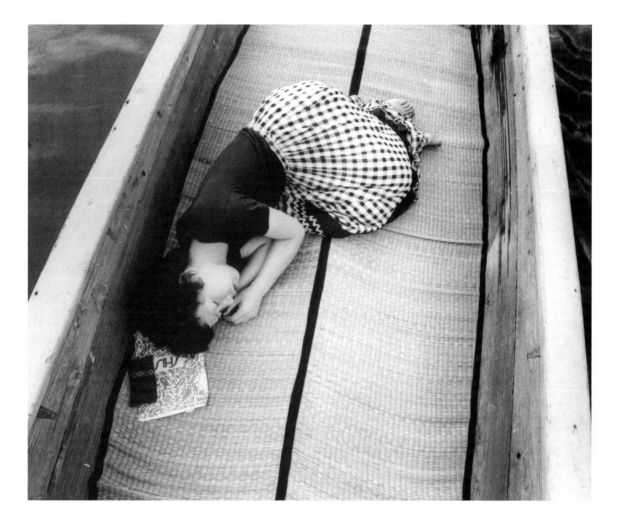

prolific photographers ever, Araki published multiple books featuring Yoko. The first of these, *Sentimental Journey* (1971), documented their marriage, honeymoon and life as newlyweds. A sequel, *Yoko My Love* (1978) continued to depict her in an extremely intimate fashion, capturing her in every conceivable candid manner. Yet another, *Sentimental Journey, Winter Journey* (1997) includes some of the photos from the first edition of *Sentimental Journey*, and documents the end of her life, when she succumbed to cancer at only 42 years old. Araki's approach to this deeply

46 Nobuyoshi Araki, 'Untitled', from *Sentimental Journey*, 1971, black-and-white print.

personal documentation of his love is artless; no moment is too mundane to record.[38] With its intense intimacy, the work of Fukase, Araki and others of their generation marked a significant break with the photography of the past in both subject and form.

The last two decades have seen a virtual explosion of work that explicitly addresses issues of identity in a critical fashion. Much contemporary work confronts gender identity, a particularly fertile theme given that gender norms within Japan have traditionally been quite restrictive. Though a Feminist movement existed in Japan in the 1970s, its impact was not nearly as widespread as it was in the West. Until recently, Japanese women's lives tended to follow well-defined paths. Young women might join the workforce, but they were generally expected to stop working once they married and had children. Consequently they were largely restricted to clerical or administrative work for a few short years until they began their careers as housewives. Though equality between the sexes has made great gains in the last two decades, Japan still lags behind the West in this regard. It is therefore unsurprising that many female photographers – the first generation of women to achieve significant success in the art world, it should be noted – consider gender in their work. It is particularly striking how many contemporary female artists have commented that they either did not recognize or were unable to critique Japan and to explore these identity issues until they had spent some time experiencing life outside of Japan. Two of the most prominent female artists to attract international attention, Mariko Mori and Miwa Yanagi, have both indicated that they felt they needed some critical geographical distance to begin to understand the issues they explore.

Mori's images from the mid-1990s refer to the stereotypes and restrictive atmosphere experienced by young working women. Her early work consisted of self-portraits in which she inserted herself into various environments that served to call attention to her incongruous placement in the scene. One of the best known, *Tea Ceremony III* (1995), featured Mori offering tea to businessmen passing by on the sidewalk, dressed in a typical 'office lady' uniform with the addition of a cyborg-inspired cap and tights (illus. 47). The men pay her no heed, despite her rather strange attire and unusual location outdoors, which Mori suggests highlights

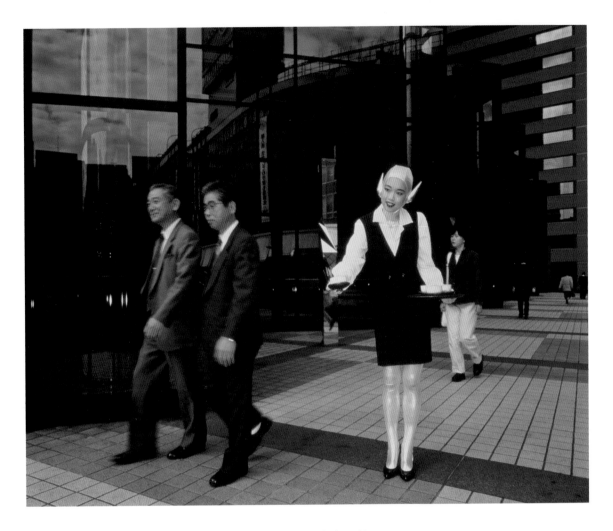

the subservient and often invisible role of women in the workplace.[39] Yanagi raised similar concerns in *Elevator Girl* (1994–8) (illus. 48). This project consisted of a series of large-scale, beautifully produced photographs of young women dressed in identical uniforms like those worn by the attractive young girls that fulfill a variety of service positions (shop greeters, lift call-girls, and tour bus guides, to name but a few). The women are artfully arranged in surreal-looking settings that are intended to highlight their role as decorative elements. In criticizing the commodification of women based on their appearance, Yanagi's work continues the long history of linking women's beauty with

47 Mariko Mori, *Tea Ceremony III*, 1994, Cibachrome print.

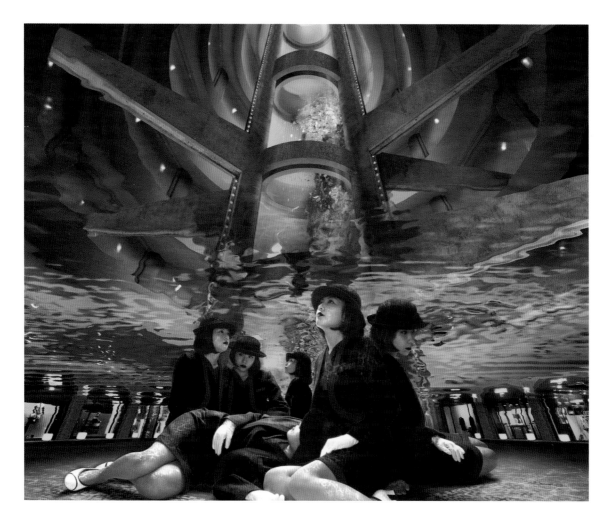

48 Miwa Yanagi, 'Elevator Girl House B4', from *Elevator Girl*, 1994–8, c-print.

Japanese cultural identity, as discussed earlier in this chapter, though she brings to the topic a new critical awareness. Her second major body of work, *My Grandmothers* (2000–) again addresses contemporary feminine identity, this time in a more playful way (illus. 49). For this series Yanagi interviews young women about their dreams for 50 years in the future, and depicts them in their old age living out the – often fantastical – lifestyles they describe. A narrative derived from the interview accompanies each image. Despite the limitations that still shape the lives of young women in Japanese society, many of the photos in this later series convey a sense of optimism and hopefulness about the future.[40]

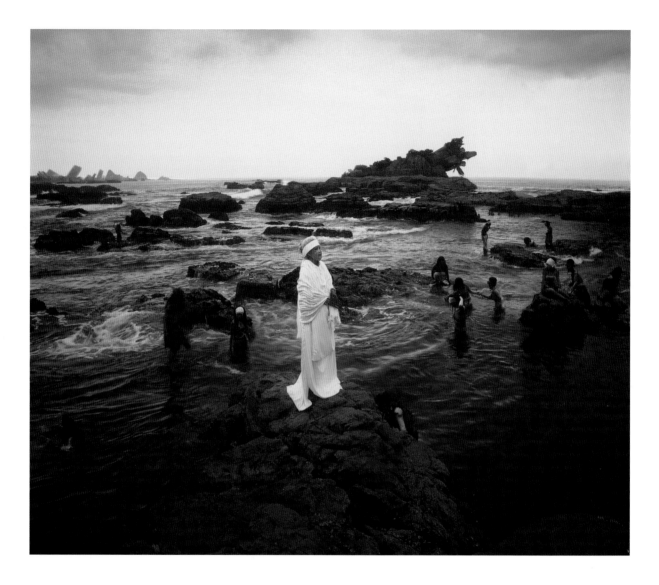

Tomoko Sawada's work continues to explore personal and cultural identity through self-portraiture, seeking to address 'the relationship between the outward appearance and the interior self'.[41] Sawada takes a playful approach as well, and though she does not necessarily set out to consider gender issues, they are often implicit in her themes. In series such as *Omiai♡* (2001) and *School Days* (2004), she draws on a number of Japanese cultural and gender clichés (illus. 50, 51, 52). Sawada repeats her own image, taking on the role of typical female stereotypes in Japanese culture, in this case the formal *miai* (arranged marriage) portrait in the former and the uniformed schoolgirl in the latter. Inspired by other photographers who take self-portraits, notably Cindy Sherman and Yasumasa Morimura, Sawada's work differs in that she does not dress up as others but always remains 'herself' in her images. Rather than assuming other personas, her concern is with how altering one's appearance affects perceptions. In a twist to the interpretation of self-portraiture, she generally does not take the images herself, but rather has friends or colleagues release the shutter. For *Omiai♡*, she had a neighbourhood portrait studio take 30 typical photos while posed in various outfits, including both traditional kimono and contemporary clothing.[42] In *School Days* her own face appears in a typical high-school class portrait as 40 different students. Though at first glance the images seem to be of different women, close looking soon reveals that they are all the same person. The repetition begs the viewer to contemplate stereotypes of Japanese uniformity.

While Sawada plays dress-up as herself, other artists have produced work in which the subjects assume other personas and sometimes other genders. Japan has a long tradition of gender-bending performance and its representation in the visual arts. This dates to the early Kabuki theatre of the sixteenth century, when men took up female roles after women were prohibited from acting, and continues to the present day with the all-female revue, *Takarazuka*, in which women play both male and female roles. Recent work by Midori Komatsubara recalls this history (illus. 53). In the series *Sanctuary* (2003–), Komatsubara depicts the romantic fantasies of gay adolescent boys, blending masculine and feminine characteristics digitally (female heads are combined with male

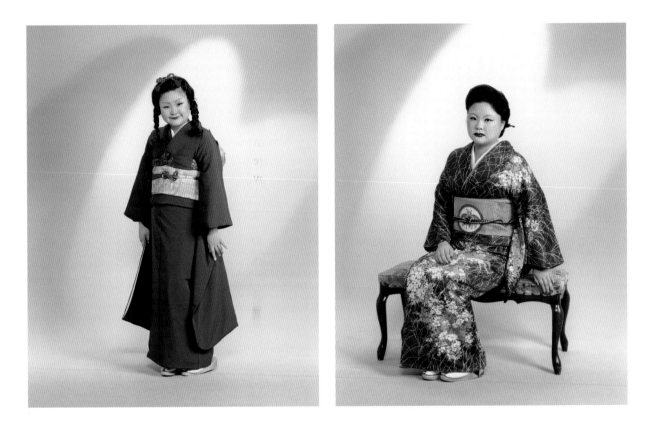

bodies). *Sanctuary* is set up as a narrative format with chapters, with the characters introduced and paired up in the first chapters. The images have a very theatrical quality to them, appearing almost as publicity stills for contemporary television dramas. Their staging and composition clearly reveals Komatsubara's interest in *anime* (Japanese animation) and *manga*. The mixture of characteristically male physical postures blending seamlessly with obvious female faces creates an unsettling effect. Komatsubara describes her intentions:

> It's not that I really want to *become* a man, but through my art I can shut off the girl part of me, if only for a time. But if I become a boy, I don't want to fall in love with a girl; I want to be loved by a boy, or I want to love a boy. In reality, as a woman, when I get into a

50 Tomoko Sawada, *Omiai♡*, 2001, digital C-print.

51 Tomoko Sawada, *Omiai♡*, 2001, digital C-print.

relationship with a man, I can feel the restrictions that I face and the female side of me becomes passive. The feeling of 'becoming a boy and wanting to fall in love with a boy' allows me to project my fantasies from any stance of the boy couple. I can be actively engaged in either role, I don't have to be passive, and I can freely claim my own identity.[43]

The project allows her to claim an active part in her own identity construction while permitting a more fluid interpretation of gender roles than might be readily accepted by society.

No discussion of gender construction is complete without touching on the work of Yasumasa Morimura. Morimura has often played with gender

52 Tomoko Sawada, 'School Days/A', from *School Days*, 2004, digital c-print.

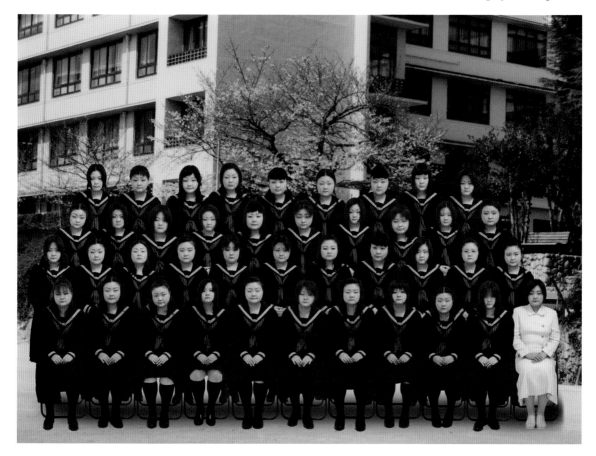

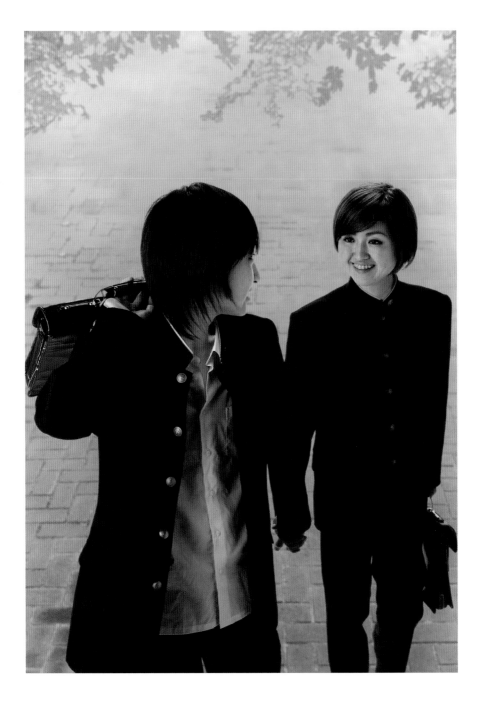

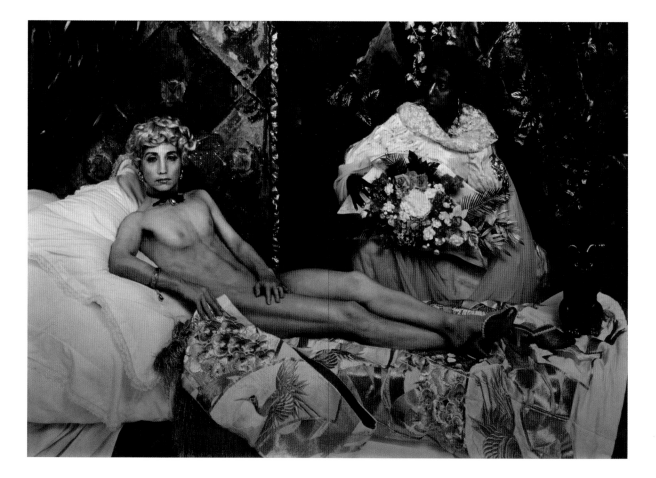

54 Yasumasa Morimura, *Futago (Portrait)*, 1988, chromogenic print.

53 Midori Komatsubara, 'Tatsuya x Yu', from *Sanctuary*, 2004, digital print.

in his photographs, producing complex images layered with symbolism. While the work of female photographers such as Mori and Yanagi may offer an explicit critique of the Japanese social system and women's roles within it, Morimura's work is much more ambiguous, and he often intentionally addresses Western, rather than Japanese, cultural icons. One of Morimura's best-known series consists of recreations of master-pieces of Western art in which he plays all of the characters.[44] In *Futago* (*Portrait*, 1988), Morimura takes on Edouard Manet's *Olympia* (1863), posing as both the prostitute Olympia and her servant. While both of the figures of the original are women, in Morimura's version they are,

85

of course, clearly men (himself). The care with which he stages the recreation and manipulates his appearance to replicate the original results in a striking similarity to Manet's painting. The uninitiated viewer may do a double take at first, realizing that something about the image seems not quite right, and eventually determining the reason – that the female subject has become a man. But Morimura slightly alters the setting, including elements that suggest Japanese culture – a good-luck cat figurine, a kimono. The resulting image hints at multiple interpretations. Is Morimura suggesting that Japan has prostituted itself to the West? Or perhaps he is commenting on stereotypes of feminized Japanese culture by taking on the role of the women? Such provocative work reveals the technical and intellectual sophistication typical of contemporary artists, who continue to address issues of individuality, gender, national and cultural identity in a variety of inventive ways.

two

Visions of War

The date 9 August 1945 is etched into the world's collective memory by one of the most iconic images of the twentieth century (illus. 55). On that day, the United States Air Force launched the second of two atomic bombs over southwestern Japan. Code-named 'Fat Man', the bomb decimated the city of Nagasaki and brought immeasurable and long-lasting pain and suffering to its victims. The photograph shows a massive mushroom cloud and thick smoke column hovering some 18,000 metres tall above the city. Despite its symbolism as a weapon of destruction, there is a powerful, dark beauty to the symmetry and abstract shapes depicted. The bombs on Hiroshima and Nagasaki ultimately brought the Second World War to a close, and in the process ended nearly a century of military activity within Japan.

War has been instrumental in shaping modern Japan. Early conflicts including the Bombardments of Shimonoseki (1863–4), the Boshin War (1868–9) and the Satsuma Rebellion (1877) marked the tumultuous end of the feudal age as Japan transitioned into the Meiji period. Not much later the Sino–Japanese War (1894–5) and the Russo–Japanese War (1904–5) testified to the success of Meiji Japan in achieving technological parity with the West, as the newly modernized military delivered decisive victories on the international stage in both battles. Japan acquired Formosa (Taiwan) and other Chinese territories as part of the armistice marking the end of the Sino–Japanese War. Following the Russo–Japanese War, Japan annexed Korea and began to advance into Manchuria. Japan played a relatively minor role in the First World War, but used the opportunity to expand its presence in Manchuria and Inner Mongolia.

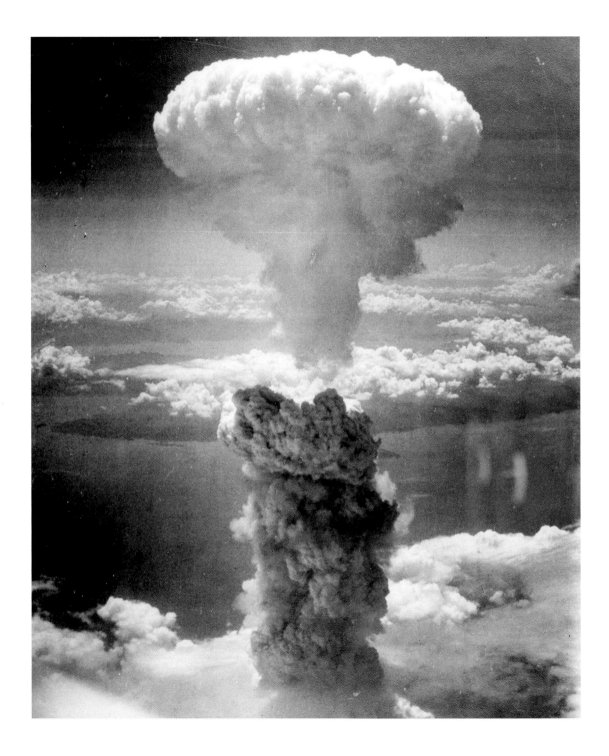

By 1918 the Japanese were moving into Siberia, further setting the stage for the Japanese imperialism of the 1930s. Intermittent fighting between China and Japan began again with the Manchurian Incident in 1931, eventually culminating in the Second Sino–Japanese War (1937–45), which in turn became part of the Second World War.

An extensive photographic record documenting all of these military endeavours exists, ranging from more obvious manifestations of war photography such as images of battlefields, battle-scarred landscapes and the signing of diplomatic treaties, to the vast body of work that recorded the physical and emotional aftermath of the Second World War and the Allied Occupation.[1] The Japanese were no strangers to visual representations of war, having long enjoyed vividly portrayed battle scenes in hand-scroll paintings and woodblock prints. Photography brought a new realism to the subject, along with the capacity for expanded documentation.

During the nineteenth century, the production of war-related imagery was directly affected by the technologies available. The ponderous wet-plate process in use into the 1880s meant that action shots were impossible, so early photos focused instead on recording the aftermath of battle or on posed images of key players. Once the dry-plate procedure became commonplace, photographers could be more daring in capturing battlefield imagery, and during the Sino–Japanese War they began to travel with the troops. A close relationship developed between photography and the publishing world as printing technologies rapidly changed around the turn of the century. The first published illustrations based on photographs were copperplate engravings, as it was not yet possible to mechanically reproduce the photographs. Publications with individual photographs tipped in were issued at the beginning of the late 1880s. During the Sino–Japanese War, the half-tone printing process allowed for widespread circulation of printed illustrations, though it did not yet have the capacity to simultaneously print both text and image on one page. At the beginning of the twentieth century, the photogravure printing process allowed text and photographs to be printed together. Thanks in part to the new technology, war-related publications enjoyed unprecedented popularity during the Russo–Japanese War.

55 *Mushroom Cloud over Nagasaki*, 9 August 1945, gelatin silver print.

89

Felice Beato, the intrepid Italian-British photographer who developed the Yokohama photography genre, was once again a pioneer in the field of war photography in Japan. Beato, already well established as a photographer, had arrived in Japan in 1863 after photographing the Crimean War and travelling around Asia. He produced some of the first Japanese war photographs when he accompanied a British-led naval squadron as they fought against the samurai of the Chōshū domain in southwest Japan during the Bombardments of Shimonoseki in 1864. The Chōshū were imperial loyalists who opposed the shogunate's new policy opening up the country. Taking up the cry 'Sonnō jōi' (Revere the Emperor, Expel the Barbarians!), they had fired on allied ships (Dutch, French, British and American) in the straits off the coast of Shimonoseki. Beato

56 Felice Beato, *Capture of the Japanese Guns of the Lower Battery at Shimonoseki, by Joint British and Dutch Forces*, 1864, large-format albumen print.

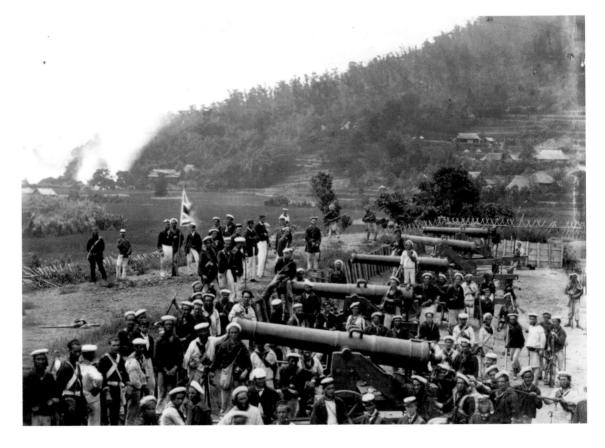

documented the Western troops capturing Japanese weapons, with one of the best-known images showing the allied sailors milling around the Japanese cannons.[2]

Beato was present at another crucial conflict marking the transition from feudal to modern Japan, a clash of the old guard against the new that ushered in the Meiji Restoration. The Boshin War (1868–9) was another battle between pro-imperial forces and those loyal to the Tokugawa Shogunate; it too was prompted by dissatisfaction over the shogunate's handling of the foreign presence. The imperial faction was led by Takamori Saigō and included men from Chōshū and Satsuma, the domain in southwest Japan whose scholars had struggled to master the daguerreotype process in the previous decade (see illus. 3). Despite the shogun's superior numbers and the advantage of being trained by French military advisers, the shogun's troops fell to the imperial loyalists. Their victory restored the emperor to power and marked the beginning of the Meiji period. Beato's photograph of Satsuma domain retainers clustered around a map plotting their strategy is striking. Ten men are shown, though only one looks up to make eye contact with the camera.

57 Felice Beato, *Samurai of the Satsuma Clan*, 1868–9, albumen print with hand colouring.

His direct gaze into the lens suggests the formidable and determined nature of the resistance.

Southwest Japan was the site of yet another conflict in 1877. The Satsuma Rebellion was the last and most significant civil war during the transition from the Edo to the Meiji period. Now Takamori Saigō led rebel troops comprised of former samurai in a fight against the government-sponsored military.[3] Though Saigō had initially supported the emperor's policies, he had grown increasingly dissatisfied and switched his allegiance. Saigō was a renowned war hero who commanded great loyalty, and this was a significant test for the young governmental regime, the first uprising to truly test the authority and capabilities of the new Western-style military establishment. The government forces proved themselves up to the challenge, ultimately quelling the dissenters and emerging victorious after some eight months of fierce fighting.

Government officials recruited leading Kyushu photographers to document the conflict. Nagasaki-based Hikoma Ueno joined forces with Rihei Tomishige, his former pupil and one of the first photographers in the city of Kumamoto, to photograph the battle site. Accompanied by a sizable entourage of porters and assistants who helped to carry their bulky cameras and supplies, Ueno and Tomishige made some 200 collodion wet-plate negatives of the scarred remains of the battlefield on which the civil war drama had played out. As film and shutter speeds were not yet up to the task of capturing live action, the images focused on the physical devastation and aftermath of the fighting. The photographers seemed intent on deliberately avoiding the carnage that no doubt littered the scene. Rather than showing bodies strewn across the sites, as Mathew Brady had in his recent photos of the American Civil War, Ueno and Tomishige concentrated instead on recording buildings pock-marked with bullet holes and the charred remains of Kumamoto Castle, which had been largely destroyed in a 74-day siege (illus. 58).[4] It seems plausible that the government entities that had ordered the commission specified that they did not wish to see the human cost of the war, perhaps fearing that such photographs might undermine public support.[5]

Japan did not engage in serious combat again for nearly two decades, until it fought China in 1894–5, battling primarily for control over Korea.

The Sino–Japanese War marked Japan's debut on the world stage as a modernized military power. Photography began to be used in a more deliberate and comprehensive fashion to record military actions. The role of photographer shifted from civilian/professional/commercial practitioners to official military affiliates. Whereas the government had commissioned Ueno and Tomishige, independent photographers, to document the Satsuma Rebellion, it now established photographic bureaus within the military service. The first of these was the Army Photographic Unit of the Land Survey Department, under the auspices

of the Army General Staff. Kanejirō Toya headed the unit, assisted by two other photographers, Kenji Ogura and Yūsei Murayama. Over the nine months of the war, they travelled with the Army and made over 1,000 images, using the glass dry-plate negatives that were by then common.[6] Representative photos exemplify a visual approach befitting the purpose of a surveying unit: they tended to show broad views of the troops engaged in manoeuvres, for example (illus. 59–60).

Count Koreaki Kamei headed a second unit affiliated with the Army. Kamei petitioned the emperor directly and received permission from the Imperial Headquarters (*Daihonei*) to accompany the Second Army unit on their campaign. Unlike Toya's group, Kamei and his team were self-funded. He was perhaps the last exemplar of the first wave of Japanese photographers, members of the upper class who had come to learn photography as *daimyo*-sponsored scholars of Western studies. Kamei was also something of a technical anomaly, as he continued to use the wet-plate process, which was significantly less convenient than the dry-plate and consequently far less suitable for the travails of war photography. More than 900 kilograms of cameras, glass plate negatives and other equipment accompanied Kamei and his assistants to the front. Because of his slower and more complicated process, Kamei's unit produced far fewer images than Toya's – roughly 300 negatives in total. Kamei would have required significant time and preparation to set up his camera and compose his shots, and the Daihonei photographs suggest the deliberateness dictated by the procedure. Like Toya's they generally illustrate expansive views of troops going about their business, a subject eminently appropriate for the limitations of the medium.[7]

The Sino–Japanese War was also significant for being the first to circulate war photographs widely in print. The war was the first to have foreign military attaches and press present. Those accompanying the troops included Georges Bigot, a Yokohama-based French artist best known for biting caricatures that were published in the journal *Toba-e*. Bigot had access to a small, portable camera, which he brought to the front and used to photograph the 1894 Port Arthur massacre of thousands of Chinese civilians and troops. This was a gruesome retaliation by the

59 Japanese Army Photographic Unit, *Advance of the Second Army Staff upon Yung-ching*, January 1895.

60 Japanese Army Photographic Unit (Land Survey Development), *Japanese Artillery Bombing Port Arthur from Fang-gu-tun*, 21 November 1894, albumen print.

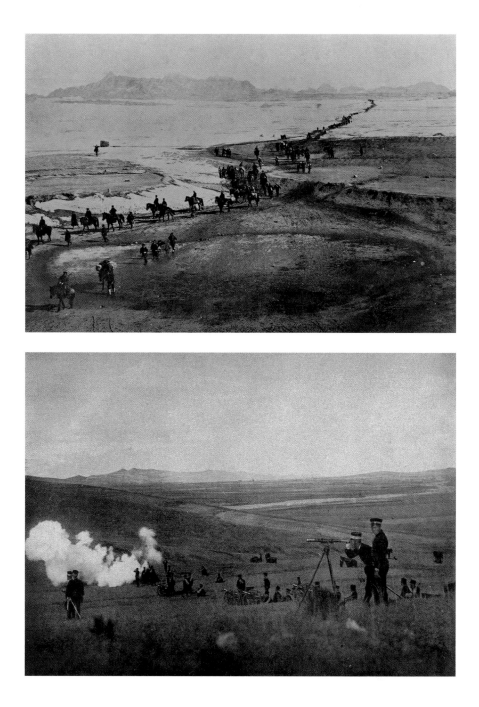

Japanese to avenge the deaths of Japanese soldiers who had been tortured and mutilated by the Chinese earlier in the war. A photolithograph based on one of Bigot's photographs was published in London by the journal *The Graphic* some six weeks after the massacre. It vividly conveyed the ruthlessness of the Japanese, showing 24 soldiers nonchalantly hovering over a mass of dead bodies with swords drawn. Sebastian Dobson has suggested that the time lag between the actual event and the publication of the image lessened its impact abroad. At the very least it made the Japanese cognizant of the necessity to exert greater control over the dissemination of images.[8]

In addition to images such as Bigot's that were published abroad, illustrated war-related magazines and journals also enjoyed broad popularity within Japan. Foremost among these was the *Nisshin sensō*

61 Georges Bigot, *The Fall of Port Arthur*, illustrated in *The Graphic* (2 February 1895).

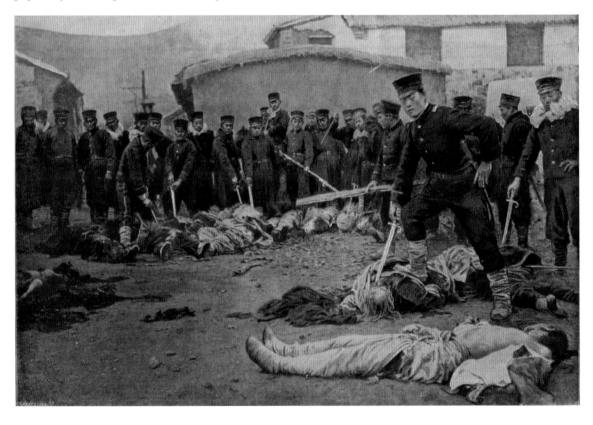

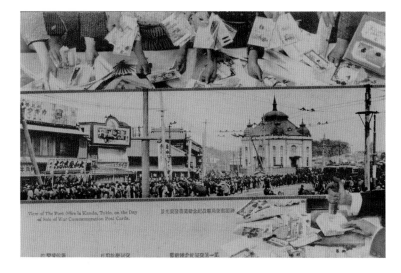

65 Artist unknown, 'View of the Post office in Kanda, Tokyo, on the Day of the Sale of War Commemorative Postcards', 1906, collotype, colour lithograph, letterpress; ink on card stock.

Soldier portraits in turn often found their way into the magazines, which reprinted images of high-ranking heroes as well as those who died in battle (see illus. 28).

The Russo–Japanese War witnessed a boom in yet another new printed medium: postcards. Postcards were a flourishing business during the war, and many featured photographs of war-related themes. A self-referential card issued in 1906 underscores the popularity of the format. It featured a photograph of throngs of people queued up outside the post office waiting for war commemoration postcards to go on sale. Other Russo–Japanese War postcards included photographs of battle scenes and portraits of high-ranking heroes.[13]

Aside from the popularity of portraits of enlisted men and the occasional image of the war dead on the battlefield, much of the war photography discussed thus far tended to focus on the more abstract or impersonal elements of war – expansive views of vast numbers of troops advancing, or detached images of the latest machinery and military equipment. While there are certainly some images of the earlier wars that put a more human face on the conflict, late nineteenth- and early twentieth-century war photographers generally seemed much more intent on conveying the Japanese mastery of war by emphasizing elements

(Photographic Album of the Russo–Japanese Campaign, Tokyo, 1904–6) and *Nichiro sen'eki kaigun shashinchō: Kaigunshō ninka* (The Russo–Japanese War: Naval, by Permission of the Naval Department, Tokyo, 1904), which included Tajirō Ichioka's images. Such photographs tended to emphasize the crisp precision and teamwork of the sailors. A half-century later, photographic books would be one of the primary means photographers employed to come to terms with the devastating aftermath of the Second World War, but the form those books would take was markedly different from the celebratory visions of the early twentieth century.

Notably, both the Sino–Japanese War and the Russo–Japanese War saw an explosion of portrait photographs of soldiers, who flooded studios to have their images made before being deployed. Of the Russo–Japanese War, the writer Lafcadio Hearn observed:

Never before were the photographers so busy; it is said that they have not been able to fulfill half of the demands made upon them. The hundreds of thousands of men sent to the war wished to leave photographs with their families, and also to take with them portraits of parents, children and other beloved persons. The nation was being photographed during the past six months.[12]

63 Artist unknown, cover of *Nichiro sensō gahō* (The Russo–Japanese War Photographic Pictorial; 1905), colour lithograph, ink on paper.

64 Tajirō Ichioka, 'Firing a Six-Inch Quick Fire Gun', from *The Russo–Japanese War: Naval*, no. 1 (1904).

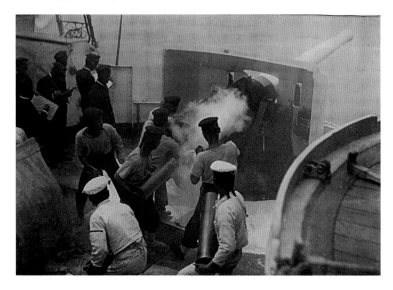

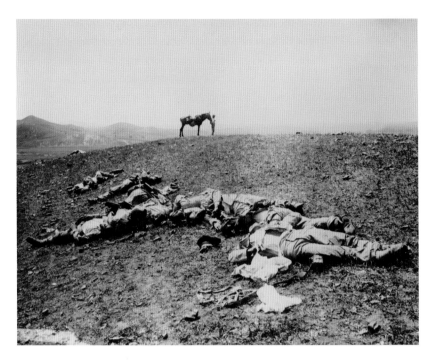

The strong links formed between war photography and the publishing industry flourished even more during the Russo–Japanese War. Beginning in 1904, printing technology now allowed text and image to be printed together on one page, as opposed to images having to be issued as separate supplements. Publications illustrated with photographs became standard, and war-related subjects proliferated. Magazines included *Nichiro sensō jikki* (True Record of the Russo–Japanese War) and *Nichiro sensō shashin gahō* (The Russo–Japanese War Photographic Pictorial), both also published by Hakubunkan (illus. 63). Thanks to the great demand, much of the photography taken at the front had explicit commercial intentions. (Earlier war photography, even when commercially available, had tended to be produced for official documentation purposes first and foremost.) Of Ogura's crew of eleven, for instance, nine men were employees or affiliates of Kazuma Ogawa's publishing enterprise.[11]

Ogawa remained the key source for commemorative albums. His publications included the 24-volume set *Nichiro sen'eki sashinchō*

jikki (Record of the Sino–Japanese War), a tri-monthly publication put out by the publisher Hakubunkan. It offered

> a multimedia blend of news and propaganda, pandering to reader appetites for nationalism by running Japanese testimonials from the front and exposés on the moral and strategic weak points of the enemy, and by listing statistics, battle records, photos of military hardware, and minutely detailed maps of military maneuvers.[9]

High-quality photographic books supplemented these periodicals. Kazuma Ogawa, the prolific publisher and photographer previously mentioned, published photos taken by Toya and his unit in commemorative albums such as *Nisshin sensō shashinchō* (Photographic Album of the Japan–China War) (Tokyo, 1895), giving them wide circulation (as opposed to Kamei's, which were privately published by his son in 1897). These various visual narratives helped to shape perceptions about the war and Japan's military success, stoking feelings of national pride in the process.

While the Sino–Japanese War made the West take note, it was Japan's victory over a Western power in the Russo–Japanese War that truly proclaimed that Japan had emerged from the Meiji period fully able to engage as an equal in the global political arena. The conflict was, again, for control over Korea and Manchuria. By this time, faster camera lenses in addition to the quicker, more portable dry-plate process enabled photographers to capture a wide range of military activity, including sequences of troops firing weapons. Kenji Ogura, one of Kanejirō Toya's photographers during the Sino–Japanese War, now led the Japanese Army Photographic Unit. Ogura's team was prolific, producing some 5,000 images. The Imperial Japanese Navy drafted some of its own officers as photographers, such as Tajirō Ichioka, whose photographs include views of various weapons being fired from the ship's deck (illus. 64). For the first time Japanese photographers showed images of the Japanese war dead. An image by Ogura himself showing the fallen bodies scattered across a hillside became one of the most iconic representations of the Japanese sacrifice (illus. 62).[10]

such as weapons technology or military precision. No doubt this was at least partly related to the technical limitations of the medium, but even after the innovations in printing of the early twentieth century and improvements in shutter and film speeds, war-related imagery most often took a dispassionate approach. Since military-affiliated photographic units produced many of the images, it was perhaps only natural for them to show the acts of war in a primarily positive light. Additionally, though there may not yet have been a strong element of censorship, such photographers were likely savvy enough to understand that presenting a coherent narrative of a strong army or navy was what best served the national interests of the budding world power.

In contrast, photographs from the 1930s and '40s are striking for often taking the opposite tactic, focusing on the human element and emphasizing the emotional aspects of war rather than the abstract military machine. By the Second Sino–Japanese War, war photography generally seemed to convey a much more intimate view of the battlefield and of life during wartime. Photographs taken in and amongst the troops vividly conveyed the physical demands: a field filled with soldiers inching forward on their bellies, tanks looming behind them, or men peeking out of foxholes with endless fields ahead, for example. Such images made the war feel present and personal, no doubt reminding the viewers at home of the

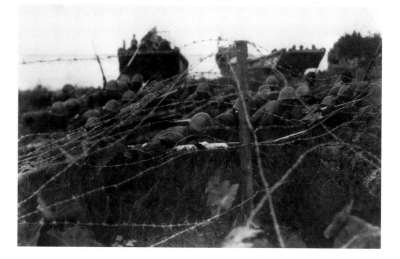

66 Manzō Haneda, *Special Naval Combat Troops Landing on Enemy Shores at Yangtze River*, 1938, gelatin silver print.

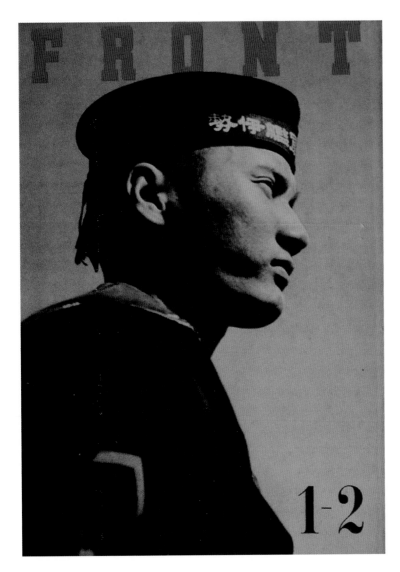

67 *Front* magazine (1942).

sacrifices their fathers, brothers and sons were making on their behalf as they inspired feelings of patriotism. By this time, of course, documentary-style photojournalism emphasizing social realism had made inroads into Japan and this style of photography was well suited to conveying a more humanizing approach to war-related imagery. Perhaps more significantly, during the Second World War the media, photography publications included, was seamlessly integrated into the imperialist propaganda

machine, used as a tool to promote the concept of 'Total War' and prohibited from showing the military in a negative fashion.[14] As fascist propaganda, war photographs were intended to evoke specific emotional responses. Though war-related images have always had a political component, the emotional component was heightened exponentially during the Pacific War in order to support the government's agenda.

During the 1930s, the government began to control both editorial and advertising content in mass-market publications. Government censorship expanded throughout the decade; by 1940 the Cabinet Information Bureau bore primary responsibility for approving and disseminating materials in support of the agenda for *Hisshō* (Certain Victory). David C. Earhart has succinctly summarized the purpose of government-controlled media:

> To produce images and texts orienting citizens within the national cause as participants in a glorious history-in-progress, one whose goals are lofty (in the case of Japan, freeing Asia from the grip of rapacious European colonial rulers and fulfilling the 'destiny' of the Yamato [Japanese] race and their ancient imperial tradition) and above all else, one that leads ineluctably to victory.[15]

Photography played a key role in achieving these aims (see illus. 36).

Two of the best-known propaganda pieces, *NIPPON* and *Front*, have already been mentioned in relation to issues of national identity. Both publications were circulated internationally, intended to help shape perceptions of Japan abroad during the 1930s and '40s. While *NIPPON*, published from 1934–44, covered a wide range of themes on Japanese culture, *Front*, published only from 1942–5, focused directly on the war (illus. 67, 68). Different issues focused on themes such as the Navy, the Air Force and Japanese activities in Manchuria. The final volume, on the topic of 'Tokyo at War', was completely destroyed in a 1945 air raid prior to distribution. Both *NIPPON* and *Front* employed dynamic graphic design and evocative photography, including some very striking examples of photomontage. They aptly demonstrate that creativity and a carefully controlled information war were not necessarily at odds with each other.

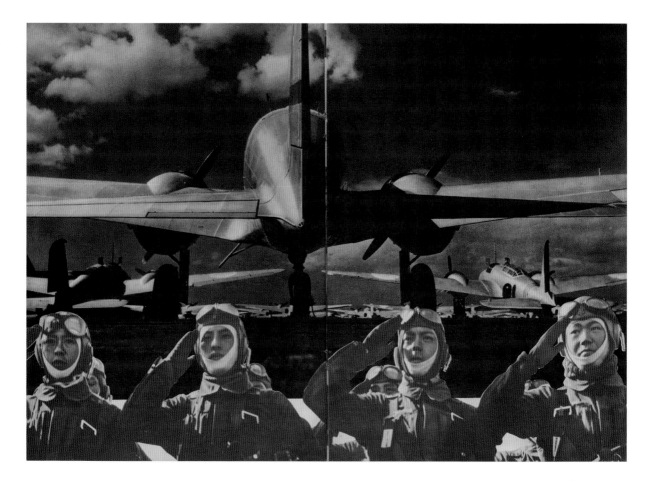

Of course war-related photography was not just restricted to documenting the troops in action. There were literally thousands of images that captured the experience of life during wartime; these, too, were carefully controlled and were generally intended to support the national agenda. The Cabinet Information Bureau itself issued a photographic publication, *Shashin shūhō* (Photo Weekly), an illustrated magazine that covered all aspects of the war, both at home and at the front. Civilians in Japan and in Japanese-occupied Shanghai, the daily life and camaraderie of the troops, members of the fire brigade back home, parades to celebrate victories – all were worthy subjects. The body of work produced

by wartime photographers is impressive, especially considering the element of censorship and the rationing of supplies. Many prominent twentieth-century photographers worked through the war, including Ken Domon, Kineo Kuwabara, Ihee Kimura and Masao Horino, to name only a few.

Some pictures emphasized the positive aspects of community during political strife. Others are more disturbing, especially those that capture the militaristic bent to so much of daily life during this period. Tadahiko Hayashi's photograph of school children depicts a circle of girls watching two boys fight wooden stick figures as part of their daily training. The wooden forms have facial caricatures attached to the heads, and presumably are meant to represent the enemy leaders Franklin D. Roosevelt and Winston Churchill. There are many similar images that show children playing at war or women training with bamboo spears in preparation for a possible invasion by foreign troops. Such photographs vividly convey how all-encompassing the fighting fever was.

Equally striking are images from late in the war (when most of the major Japanese cities were under repeated enemy air attacks) that show people tending to their daily needs in an effort to retain some semblance of normal life among the chaos. Yahachirō Bessho's photograph of a

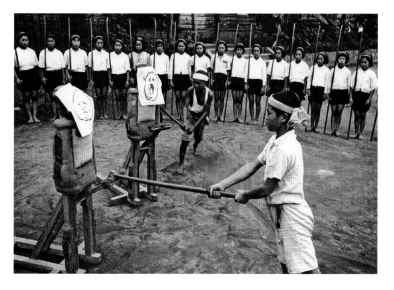

69 Tadahiko Hayashi, *Defeating the British and Americans, Yamanashi Prefecture, Shioyama Elementary School*, 1943, gelatin silver print.

105

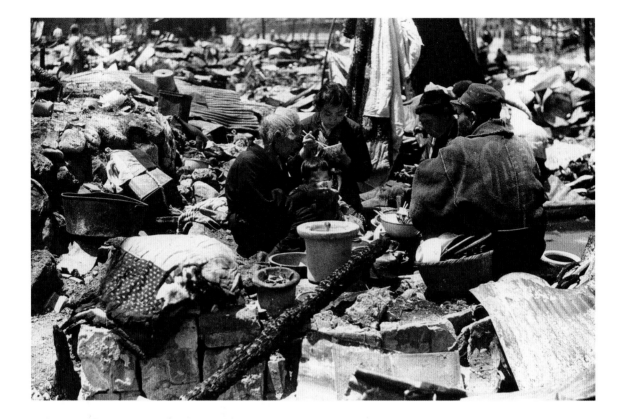

family eating is set amidst the rubble of a completely devastated Yokohama neighbourhood. Behind them a few garments appear to hang down from a post, but everything else surrounding them has been flattened and is in disarray. Despite this they sit stoically, three generations coming together to share their meagre meal. Another image by Bessho, taken from a raised vantage point, looks down into a public bath in Tokyo. The roof has been stripped away, but the partition separating the bath into two sides is still present. Women and children go about their bathing routine to the left, men to the right, with the background once again revealing the debris-filled streets surrounding the bath. Such images poignantly convey the difficulties of life during wartime.

The Japanese experience of the war was not restricted to those who lived in Japan at the time. In the United States a significant body of work

70 Yahachirō Bessho, *Family Eating in Yokohama Amidst Bomb Damage*, 1945, gelatin silver print.

was produced by Toyo Miyatake, a Japanese-American who photographed his life in the Manzanar war internment camp in California. Executive order 9066, issued by the United States government in May of 1942, commanded 'alien enemies' to report to one of ten detention centres scattered throughout the western part of the country. The detainees were forbidden from having or using cameras, but Miyatake managed to bring in a lens and film holder. He had a friend make a wooden camera and at first photographed secretly. When Ralph Merritt, the director of Manzanar, learned of this, he allowed Miyatake the camera, but in order to follow the law, he dictated that a non-Japanese person should actually release the shutter, following Miyatake's instructions. Eventually Merritt dropped this premise and permitted Miyatake to operate a photo studio as part of the Manzanar Cooperative. Thus Miyatake was ultimately able to document the internment camp experience relatively freely. While there are certainly photographs that capture the tension felt by those whose loyalty to the United States was under question, overwhelmingly the images are striking for their sense of normalcy. Men pounding *mochi* (sticky rice gruel) during New Year's celebrations, high school graduates

71 Toyo Miyatake, *The Three Majorettes*, c. 1944, gelatin silver print.

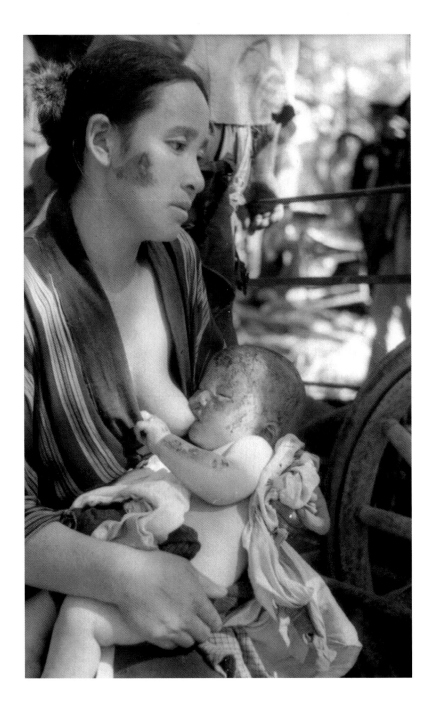

gathered in caps and gowns, drum majorettes smiling jauntily in front of a backdrop of snow-capped mountains: all captured normal, everyday life as it went on behind the security fences of Manzanar (illus. 71).[16]

The two atomic bombs dropped by the United States in August 1945 ushered in the end of the war. Japan officially surrendered at a ceremony on the US battleship *Missouri* on 2 September 1945, bringing the Second World War to an official close. Photographs of the devastation caused by the bombs are some of the most powerful visual records of modern history. Several photographers were able to capture the immediate aftermath of the bomb, though their photographs were not widely known for some time thanks to an embargo on their circulation by the Allied Forces who occupied Japan from 1945–52.

Yōsuke Yamahata had been working as a military photographer and had just passed through Nagasaki; after the bomb dropped he was ordered to return to the city to record the damage. Several of his most moving images have been widely circulated since the initial ban was lifted in 1952. One of the photographs depicts a small boy holding a rice ball, his skin smudged by the ash; another shows a weary and shocked mother nursing a baby, who would later die (illus. 73, 72). These photos are particularly poignant and their widespread appeal as symbols of the bomb is easy to appreciate. They avoid the more graphic depictions of the devastation; neither is truly gruesome. They both highlight the human element, creating an emotional impact by focusing the weakest among us. Thus they aptly convey the suffering experienced in strongly sympathetic terms. Their re-use in multiple contexts over the next 50 years, including being displayed in the iconic exhibition 'The Family of Man', testifies to their enduring power.[17] Other images are just as moving for their lack of human presence, such as the panoramic views that show the complete devastation of the area, or the photograph Eiichi Matsumoto took some five miles from ground zero that shows the outline of a figure etched onto the wall (illus. 74).

The immediate post-war period inaugurated what the photography critic Ryūichi Kaneko has called 'the invisible war': the trauma of dealing with the aftermath – both physical and psychological – of the war

72 Yōsuke Yamahata, *Mother and Child Waiting for Medical Treatment, Nagasaki,* 10 August 1945, gelatin silver print.

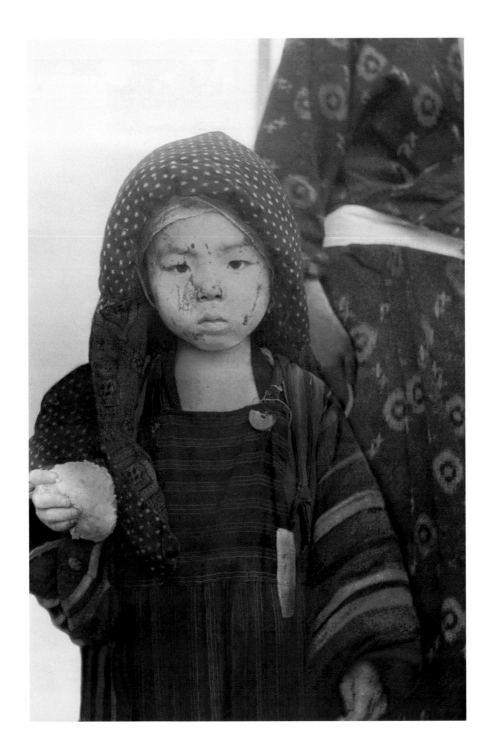

experience. In the decades following Japan's defeat, Japanese photographers produced some powerfully evocative images that embodied this process. Photography was used to help redirect the mood of the country, as seen in the photo of Hirohito and General MacArthur discussed in the previous chapter (see illus. 39), and photojournalists such as Tadahiko Hayashi recorded life in Japan under the Allied Occupation. (He later published a collection of images from 1946–55 titled *Kasutori jidai*, or Days in the Dregs.) But the most poignant images would come in the form of photographic books produced well after the ban on photographs

related to the bombs had been lifted, the Occupation had ended and some sense of normalcy had returned. Then the Japanese could finally start to come to emotional terms with the war.

There are a number of seminal photo-books that take the devastation wrought by the atomic bombs as their subject. One of the first bodies of work to draw attention to the victims of the bomb was the documentary photographer Ken Domon's book *Hiroshima*, published in 1958. Domon was particularly well suited for the project, not just in terms of his straightforward stylistic approach, but also because his anti-war stance had seen him dismissed from his government contract working for the International Association for the Promotion of Culture (*Kokusai bunka shinkōkai*) in 1943. *Hiroshima* documented in graphic black and white the physical suffering of the survivors. The photos focused – sometimes in gruesome detail – on common experiences in the aftermath of the

76 Ken Domon, 'The Kotanis', from *Hiroshima* (1958), gelatin silver print.

bomb. Life in the hospital, daily routines at a school for children blinded by radiation, a man confined to bed for thirteen years because of illness, operations on distorted limbs, keloid scars and skin grafts, marriage between two survivors: the sequence of images provides a moving account of daily life for the victims (illus. 76). Domon's documentary style humanized the subject, presenting an unflinching gaze on their suffering but also showing that life continued on.

Domon's photographs of Hiroshima were paired with those of Shōmei Tōmatsu in a second work chronicling the aftermath of the

bombs, *Hiroshima-Nagasaki Document 1961*, published by the Japan Council Against the Atomic and Hydrogen Bombs. With copies issued in English and Russian, it was clearly intended to send a message to the two superpowers at the centre of the Cold War conflict. Since Domon had already photographed in Hiroshima, Tōmatsu was commissioned to cover Nagasaki. In addition to the victims, he photographed a variety of objects from the Nagasaki Atomic Bomb Museum as well as the ruins of the Catholic cemetery in the Urakami neighbourhood. Though also influenced by documentary photography, Tōmatsu took a more expressive approach in contrast to Domon's studied objectivity. By 1960, the influence of William Klein and Ed van der Elsken, who had both visited Japan, was spreading. Tōmatsu and other photographers such as Daidō Moriyama adapted the harder-edged, darker style of those Western photographers to create a more personal vision, resulting in work that aptly conveyed the emotional intensity of lingering feelings of despair and angst. While Tōmatsu's images of people are powerful, the photos that show the effects of the bomb on inanimate objects are particularly mesmerizing. One of the best known shows a bottle distorted from the heat of the blast that has morphed into a contorted organic form suggesting a human limb (illus. 77). It serves as a vivid visual metaphor symbolizing the tremendous suffering and loss of life brought about by the bomb. A second compelling book on this theme, *<11:02> Nagasaki*, published in 1966, further emphasized the twisted, sad poetry of these damaged artefacts.[18]

The Japanese Imperial Forces were formally dissolved during the Allied Occupation, and Article 9 of the revised 1947 constitution proclaimed:

> Aspiring sincerely to an international peace based on justice and order, the Japanese people forever renounce war as a sovereign right of the nation and the threat or use of force as a means of settling international disputes.

Since then Japan's military has been limited to Self-Defence Forces. This outcome of the US-led Allied Occupation resulted in a prolonged American military presence and a complex relationship with the United

78 Kikuji Kawada, page from the photo-book *Chizu* (The Map) 1965.

States that has continued to shape Japanese culture in many ways. Another important photo-book spoke directly to this interaction and to the lingering presence of wartime memories. Kikuji Kawada's *Chizu* (The Map), published on the twentieth anniversary of the Hiroshima bomb (6 August 1965), took the bombing and subsequent influence of American culture as its focus. Kawada photographed symbols of each culture: Coca-Cola bottles, televisions and cigarettes for the US, framed portraits of young soldiers, uniforms and other war memorabilia for Japan. The book consists of a series of gatefolds, and as the pages are opened they reveal dense, layered imagery: a crumpled, stained Japanese flag opens to a view from inside the Atomic Bomb Dome revealing bright, glaring light filtering down, for example. Although it predates the Provoke group by several years, it employs a similar rough, edgy style,

79 Kikuji Kawada, page from the photo-book *Chizu* (The Map) 1965.

with abrupt angles, compositions sharply cut off and high contrast. Kawada's dark vision is in many ways a visual culmination of post-war Japanese angst.[19]

Japanese photographers have continued to produce noteworthy records of war since the Occupation. Japan had a supporting role as a strategic base for US involvement in Korea and Vietnam. Having recently survived the only nuclear attack in world history, the Japanese were not merely dispassionate observers of the succeeding conflicts in Asia, despite their limited military power. Their unease ultimately culminated in student riots in the late 1960s, further discussed in the next chapter. Japanese photojournalists took some of the most memorable images of the Vietnam War. Kyōichi Sawada, who worked for the United Press International, garnered worldwide attention for his dramatic work when he won a Pulitzer Prize for his coverage of Vietnam. Two of his photos were named 'World Press Photo of the Year': a scene of a mother and her children struggling to cross a river in order to escape US bombing in September 1965 (illus. 80) and a view of American troops dragging the body of a dead Viet Cong soldier behind a tank, from February 1966.

The Second World War and its aftermath have provided some of the most profoundly moving and visually compelling subject-matter in all of Japanese photographic history. The complexity of US–Japan relations since the war has continued to provide fodder for photographers in recent decades. Images documenting this relationship are perhaps not, strictly

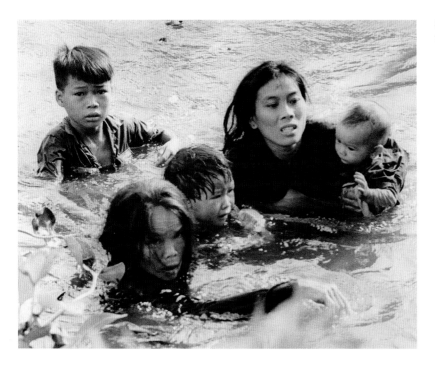

speaking, war photography, but it seems apt to conclude with this ongoing body of work, as it underscores the lasting ramifications of the Second World War. Many photographers have explored tensions arising from the ongoing American military presence. Tōmatsu, who came of age and took his first photographs during the Occupation, vividly recalls the impact of Americanization during his formative years. He has continued to examine the effect of American culture on Japan from the 1950s onwards. From 1969 to the 1970s he took a number of images on the island of Okinawa, which has been significantly influenced by the US military. While living there in 1972, he started taking photographs in colour rather than black and white, a shift he has described as related to 'de-Americanizing' himself.[20]

Keizō Kitajima focused on Okinawa as well. In 1980 he shot a series of images around Koza, the red-light district near the Kadena Air Force Base. Following in the footsteps of his mentor Daidō Moriyama, Kitajima's views emphasize the grittier aspects of the local nightlife and are printed with an inky blackness that subtly suggests the tensions between the locals and the foreign troops. The series was recently re-released as

81 Kaoru Ishimoto, *Sensō haikyo* (War Ruins), 2006, C-print.

Back to Okinawa 1980/2009, testifying to the ongoing interest in the theme. And contemporary photographers continue to produce work that reflects on Japan's wartime experiences, such as the recent photo-book *Sensō haikyo* (War Ruins, 2006) by Kaoru Ishimoto. Ishimoto explores the traces of the Second World War that remain more than 50 years later, photographing the rusted remains of the defence works on Hahajima ('Mother Island'; part of the Ogasawara Islands mentioned in the previous chapter in relation to the process of nation-building).

Picturing the City

One of the most popular and most photographed locations in contemporary Tokyo is the Shibuya Crossing outside Shibuya station. Home to a bustling shopping district and filled with neon billboards and hawkers trying to entice customers, the area draws a lively crowd at all hours of the day. Known as the world's largest pedestrian scramble, hundreds of people hurriedly traverse the pentagon-shaped intersection in all directions once the traffic lights turn red. The best view of the action is from a second-story Starbucks that borders the crossing. Ubiquitous in Japan as elsewhere, this branch of the coffee shop is allegedly the busiest in the world. During peak hours people queue up to wait for one of the prized window seats looking down onto the scene.

In 1990, Tokihiro Satoh made an image of this location that captures the area completely void of people, seemingly a remarkable feat given the site's hectic character (illus. 82). The image was part of an ongoing series of urban and rural landscapes that he has described as 'breath-graphs' or 'photo-respiration'. Satoh's technique involved using a large-format camera and exposing the negative from one to three hours. During the lengthy exposure, he moved about the space, marking his movements in front of the lens with light (a torch or flashlight in nighttime exposures, a mirror reflecting sunlight during the day). The result is a fascinating image of Shibuya Crossing that despite being devoid of people bears traces of human presence in the dots of light that are scattered throughout the scene. Satoh chose his locations for their social or historical significance. Of Shibuya he has said:

formal beauty ultimately reveals implicit social commentary on urban life as well, as in the case of Satoh. The second approach grows out of a more documentary-influenced tradition and concentrates on expressing human experience within urban life: people on the streets and the pleasures and pastimes of the urban environment.

During the nineteenth century, photographers primarily made images of the more positive aspects of urban development. As photography studios tended to be located in urban centres, there were few photographers who did not turn their cameras on their immediate surroundings during this period of dynamic change. The government played a key role, often employing artists to document local progress as they constructed new roads, railroads and Western-style buildings. Kenzō Tamoto has already been mentioned as recording the development of Hokkaido, but a similar phenomenon played out in cities throughout the country. Officials commissioned Matsusaburō Yokoyama in Tokyo, Rihei Tomishige in Kumamoto and Hikoma Ueno in Nagasaki to document municipal projects, to name just a few examples. These images almost universally convey a sense of pride in progress. Panoramic sequences that showed an all-encompassing view of the city were common, as were closer views of individual urban landmarks. One well-known landmark was the Mitsui Building near Kaiunbashi in Tokyo, which Kuichi Uchida photographed shortly after its completion in 1872 (illus. 83).[6] Designated as the first national bank, the building was a symbol of modernity both for its Western construction and its intended function. It thus fully embodied the early Meiji concept of *bunmei kaika* or 'civilization and enlightenment'.

Other famous landmarks were intricately linked to the pleasures of the urban environment. One of the most distinctive was the Ryounkaku building in Tokyo, which opened in 1890. It was designed by the British engineer William K. Burton, the same Burton who was fundamental in promoting the late nineteenth-century art photography movement. The building was an engineering feat that housed Japan's first lift and, at twelve storeys high, it towered above the surrounding neighbourhood. Located in the amusement district of Asakusa (it was also known as the 'Asakusa Twelve Storeys Building'), it offered both spectacle and

total population. Since 1980 more than 80 per cent of the population has been concentrated in urban areas, the majority scattered along the cities of the eastern seaboard on the main island of Honshu (these include Tokyo, Yokohama, Nagoya, Osaka, Kobe, Okamoto and Hiroshima, from east to west). Approximately one-fifth of the Japanese population lives in the greater Tokyo metropolitan area alone.[5] City living is something the vast majority of Japanese people have in common, and thus documenting the urban environment has been a natural mode of creative exploration for a great many photographers. There are a number of contemporary photographers with very lengthy careers who have either focused solely on or returned repeatedly to urban themes.

In some ways the history of the modern Japanese city is one of destruction and rebirth. Cities have been repeatedly decimated by catastrophes both manmade and natural (Japan famously has one of the earth's most active seismic regions). The most significant events over the last 100 years include the Great Kantō Earthquake, which destroyed most of Tokyo in 1923, the firebombing of Tokyo and other cities during the Second World War, the dropping of the bombs on Nagasaki and Hiroshima at the end of the war and the 1995 Kobe earthquake. The camera captured both the damage and the reconstruction as the city rose again each time. For most of the twentieth century, repeated disasters provided the impetus for a seemingly endless cycle of constructing new buildings and updating infrastructure with the latest technology, linking the city with a strong narrative of progress.

Two coexisting general approaches may be discerned throughout most of photographic history: photographers have emphasized either the 'absence' or 'presence' of human activity. The first approach focuses on the physical manifestations of the urban landscape. Before the development of faster lenses and cameras, by necessity images tended to record fixed objects: buildings, streets, transportation and technology. In the various artistic movements of the twentieth century that emphasized a formal approach to photography, the dense landscape of the city provided an endless variety of visually compelling structures and forms. One school of contemporary photographers continues this interest in form, though often photography that first appears to embrace a strictly

collapse of Japan's bubble economy of the 1980s. His distinctive methods provide an innovative interpretation to a theme underlying the work of a number of Japanese photographers over the last two decades: the malaise and anxiety of contemporary city life in a period of economic uncertainty and social flux.

From the time Louis-Jacques-Mandé Daguerre took his first image of a Parisian street scene in 1839, photography has been intricately connected to the depiction of urban life.[2] The roots of Japanese photography are also tied to the city, as the technology initially entered through foreigners arriving in the key port cities of Nagasaki, Hakodate and Yokohama in the late 1850s. As photography quickly spread, the first Japanese-owned studios were opened in the early 1860s in the urban centres of Tokyo, Yokohama and Nagasaki.[3] Osaka, Kobe and Kyoto soon followed in witnessing the rapid expansion of photography studios. Urban development and the transformation of feudal Japan into a modern nation-state went hand in hand. Photography was a key import symbolizing the latest in Westernization and progress and it naturally lent itself to capturing the rapidly changing national topography.

While urban modernization was a key element of the Meiji government agenda, a strong urban culture already existed in Japan prior to the Meiji period. Edo, the feudal name for Tokyo, was one of the largest cities in the world in the eighteenth century, with a population of over one million, while Osaka and Kyoto both had half a million residents.[4] The technological development and rapid modernization of urban centres was one of the most impressive accomplishments of the Meiji period, and the urban population quickly expanded as a result of industrialization in the second half of the nineteenth century. Opportunities in the cities continued to draw the population away from rural areas throughout the twentieth century. During the Taishō era, a new class of white-collar workers developed as modern companies grew. These workers were the primary consumers and subjects of a thriving urban culture that lasted until the escalation of Japanese militarism in the 1930s. Despite the significant devastation of nearly all the major cities caused by widespread bombing in the Second World War, the urban population nearly doubled from 1950–60, climbing from 37 to 65 per cent of Japan's

It is a kind of monument of Japan's rapid bubble-economy expansion [of the 1980s], and it is also a pulsating hub of activity in modern Tokyo. It has both vitality and 'weight', and at the same time it possesses a peculiar emptiness that reflects the post-bubble economy. In my image, the people disappear and the scene takes on these intangible aspects.[1]

Satoh suggests that the absence of human presence in the photo signifies the psychic emptiness of the urban consumerist landscape following the

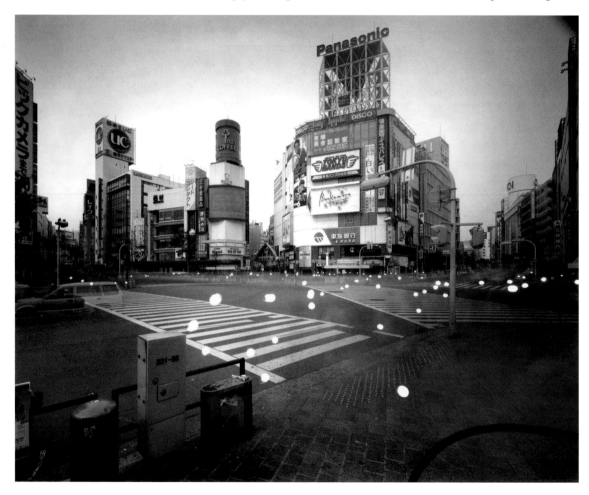

82 Tokihiro Satoh, *Photo-respiration #87 Shibuya*, 1990, gelatin silver print.

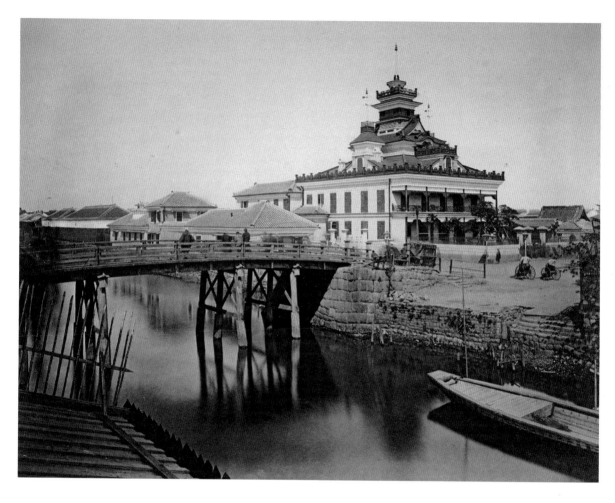

83 Kuichi Uchida attrib., *View of Mitsui Building, Tokyo*, 1873, hand-tinted albumen print.

entertainment. It was frequently photographed, appearing in numerous souvenir photos and postcards until it was damaged beyond repair in the 1923 earthquake (illus. 84). This structure has additional relevance to the history of photography, as one of the best-known photography exhibits of the nineteenth century helped to celebrate its opening. The display consisted of 100 Tokyo geisha photographed by Kazuma Ogawa. As it turned out, the lift did not work properly. As a means of enticing patrons to make the demanding walk to the top of the tower, Ogawa's photos were put on display.[7]

Urban development and the sites of city leisure were favoured themes for many nineteenth-century photographers. However, the early twentieth-century art photographers of the Pictorialist tradition were generally uninterested in the urban environment as a subject. They were drawn to still-life, portraits and landscapes instead. When art photographers did turn their attention to the city, the alternative printing techniques and soft-focus they employed created visions of a romanticized urban space. An illustrative example is *Smoky City* by Ōri Umesaka (illus. 85). It depicts a view of buildings and houses against a backdrop filled with dozens of smokestacks spewing thick black smoke

84 Kōzaburō Tamamura, *View of the Twelve-storeyed Pagoda at Asakusa Park, Tokyo*, c. 1895, hand-tinted albumen print.

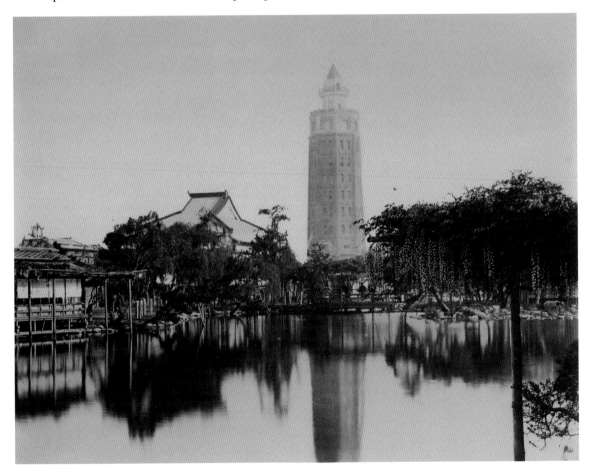

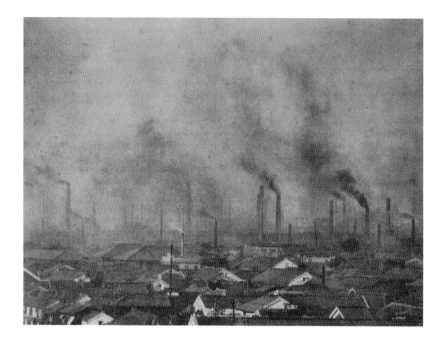

85 Ōri Umesaka, *Smoky City*, 1924, gum bichromate photograph.

into the sky. Such images perfectly illustrate the typical Pictorialist style and also neatly fit the narratives of progress. They treated urban industrialization as a thing of aesthetic beauty with no trace of irony or regard for its potentially negative impact on society or the environment.

If early art photography avoided the urban sphere, the next major movements celebrated it. Photographers fully embraced the thriving urban culture that dominated the 1910s and '20s. Prior to the 1923 earthquake, Japan's economy boomed, bringing newfound prosperity to a flourishing urban and new suburban middle class. The climate of economic and political stability helped to foster an interest in individualism, as opposed to the historical emphasis on family and group relationships. This new individualism went hand-in-hand with the anonymity and autonomy of urban life.[8] The various coexisting photographic styles lent themselves equally well to depicting the dynamic metropolis, with New Photography and realism being particularly suitable for the subject. The former led to a strongly formal approach, breaking down the elements of the city into patterns and angles, while

the latter engendered a snapshot-style street photography that captured vibrant city lifestyles.

As artists started to move away from Pictorialism and directed their attention to more avant-garde, European-influenced styles, the Great Kantō Earthquake struck Tokyo and its environs on 1 September 1923. It destroyed three-quarters of the city, killing more than 100,000 people and causing significant disruptions to life in Tokyo and to the broader Japanese economy. It also led to a period of dynamic rebuilding, with new Modernist architecture transforming the appearance of the cityscape. For the New Photography movement that arose in the aftermath, the rebuilding was symbiotic. New Photography artists reacted against Pictorialism by emphasizing the mechanized nature of the camera and eliminating any 'personal' interpretation of subject-matter. They were drawn to symbols of technology and progress, such as steel structures or innovative architecture. The constantly changing face of the city and the latest uses of new industrial technology and machinery provided steady inspiration for a new aesthetic focused on the marvels of the machine age. A collection of images published in Masao Horino's 1931 photo-essay *Dai Tokyo no seikaku* (The Character of Greater Tokyo) focusing on railroads and industrial sites perfectly illustrates this trend (illus. 86). The abstract beauty of shapes formed by intersecting power lines and train tracks highlights the visual appeal of the contemporary urban environment.[9]

Though Tokyo led the country in new construction, this inspiration was by no means confined to the Tokyo-based photographers. The role of photography clubs in promoting Modernist photography has already been mentioned. Notably, these clubs were urban entities: they could be found in most cities and thus helped drive the enthusiasm for urban subjects. The Naniwa Photography Club in Osaka, founded in 1904; the Tanpei Photography Club, also in Osaka, begun in 1930; the Ashiya Camera Club, founded in 1930 in Ashiya (near Kobe); and the Zen'ei shashin kyōkai (Avant-garde Photography Association) of Tokyo were just a few such groups.[10]

Iwata Nakayama was a key figure in promoting new artistic ideas.[11] Nakayama had operated a photography studio in New York City in the early 1920s and followed that with a stint in Paris. He returned to Japan

86 Masao Horino, *The Character of Greater Tokyo*, 1931, gravure printing.

in 1927, opened a studio in Kobe two years later, and subsequently founded the Ashiya Camera Club. Thanks to his experience in New York and Europe, he was intimately familiar with the latest avant-garde styles in the West and had direct contacts with artists there. Though Nakayama ultimately worked in a number of different Modernist styles, his images of the city of Kobe in the 1930s often embodied New Photography principles. A night scene from 1939 is representative (illus. 87). It shows a sharply oblique view of high-rise buildings on a darkened street. Bright neon lights line the facades of the structures, breaking up the inky darkness with starkly contrasting whites. The image aptly conveys the glitter and energy of the modern city in striking formal terms as it

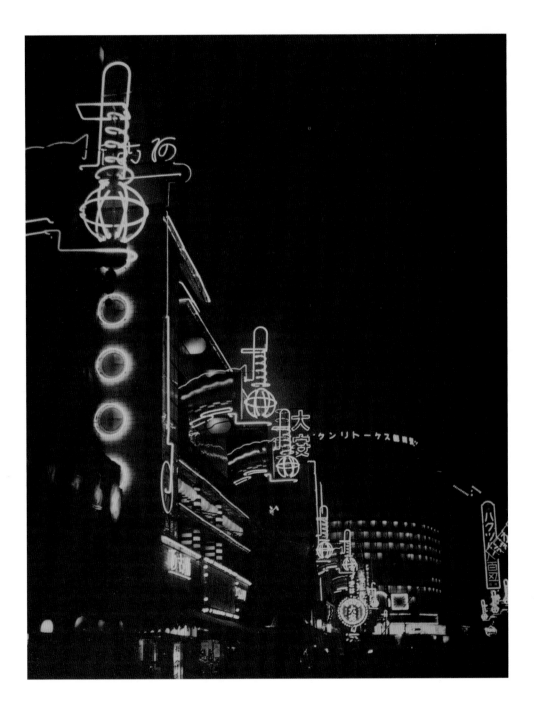

87 Iwata Nakayama, *Night View of Kobe (Shinkaichi)*, 1939, gelatin silver print.

illustrates the photographer's skill in photographing with challenging lighting conditions.

In nearby Osaka, Sadao Iwasa of the Tanpei Photography Club produced another compelling image of urban development (illus. 88). Iwasa turned his attention to the construction of the new Osaka subway. His *View of Construction Site* from 1937 takes four scenes of the same work site, shot through the framework of a large window, and combines them into a single photomontage. Each section of the sequence shows men moving about the workspace, pushing a construction dolly as they go about their labour. Though enough detail is visible to determine what the figures are doing, the images are relatively high contrast and are set against a stark white background, creating something of a shadow effect. The subject, the composition and the photomontage technique all combine to create a distinctly modern interpretation of urban activity and progress.

In contrast to the formal emphasis of the Nakayama and Iwasa images, photographers working in the photorealist mode recorded daily life. A street snapshot taken in 1928 by Kōyō Kageyama of three modern girls walking down the street vividly captures the spirit of the times (illus. 89). The modern boy and modern girl (*moba* and *moga* in contemporary parlance) were one of the most visible symbols of the new urbanism. *Moga* and *moba* were the young dandies who dressed in Western clothes and enjoyed urban pleasures such as shopping in the Ginza district in Tokyo, drinking in cafes and going to the theatre. With cropped hair, floppy hats and the latest fashions, Kageyama's subjects perfectly embody the lively energy of this dynamic urban youth culture. Another well-known documentary-style photographer during this period was Kineo Kuwabara. Kuwabara photographed daily life in pre-war Tokyo, publishing widely in photo-magazines of the 1930s (see illus. 7). An extremely prolific observer of city life, Kuwabara's images of the 'lost' Tokyo of the 1930s that was decimated in the Second World War gained renewed interest decades later.

Following the Second World War urban development took on a heightened urgency, as so much of Japan lay in ruins (see illus. 70). Documentary photographers recorded the rebuilding of Japan under the Allied Occupation. Ihee Kimura described the uncertainty of the

following pages:
88 Sadao Iwasa, *View of Construction Site (Osaka)*, 1937, gelatin silver print.

89 Kōyō Kageyama, *Moga ('modern girls') Wearing Beach Pajama Style*, 1928, gelatin silver print.

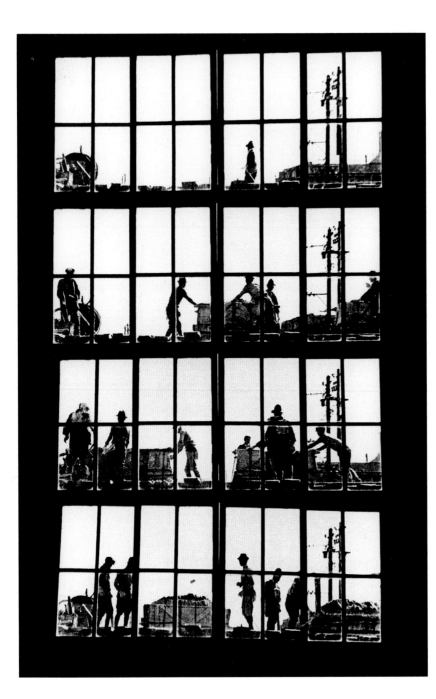

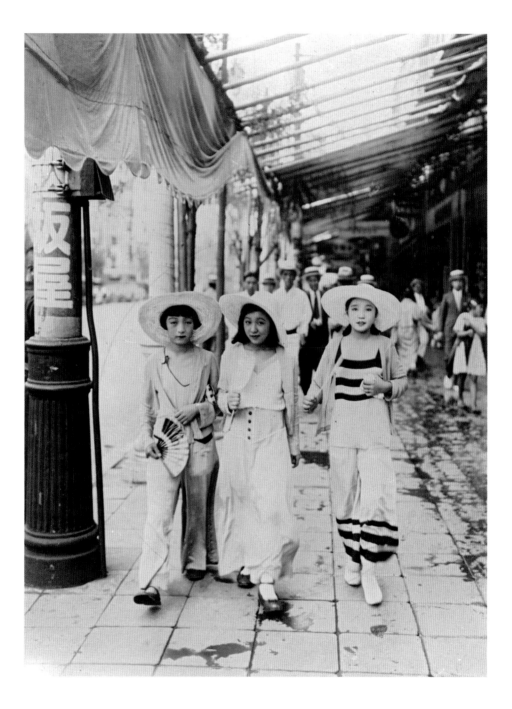

90 Ihee Kimura, *View of Nihonbashi*, Tokyo, 1945, gelatin silver print.

immediate post-war period in an essay from 1956. He had been working for the news bureau of the Imperial Army during the war. Once it folded, he had no obvious source of work and no money to build his own darkroom. He was certain he would become destitute, and even once he started getting commissions again, the first projects he was involved with frequently ended due to financial concerns related to post-war hyperinflation. Kimura's first post-war assignment was to photograph daily life in Tokyo for the Bunkasha, the new version of the Imperial Army news bureau, despite the fact that both he and the city itself were still very unsettled.[12] A view of people lined up to buy goods along a destroyed road in Nihonbashi captures life in Tokyo amidst the confusion. Through the Bunkasha he published the bilingual book *1946 Nen Aki no Tokyo* (Autumn 1946 in Tokyo). Kimura continued to document Tokyo through its recovery into the next decade, recording all aspects of city life as Japan returned to normalcy. The straightforward style he employed was emulated by the many other urban photojournalists who thrived during the 1950s (illus. 91).[13]

91 Ihee Kimura, *Ginza*, Tokyo, 1954.

The city has been a primary subject for photo-books from the 1950s to today.[14] Their themes range from recording the environmental destruction caused by widespread building to capturing the sense of alienation and loneliness that is often a by-product of existing in a vast and impersonal urban setting. One of the first books to depart from the dominant documentary style of the 1950s was <11:02> Nagasaki (1966) by Shōmei Tōmatsu. As discussed in the previous chapter, Tōmatsu was involved in one of the most significant early works to address the aftermath of the atomic bombs, Hiroshima-Nagasaki Document 1961. His second project stemming from this theme was envisioned as an exploration of the city of Nagasaki as well as a record of the damage. <11:02> Nagasaki was not just about the bomb, but the city itself. Tōmatsu described his vision:

> There's a unique quality to the city of Nagasaki that was built up after the bomb that distinguishes it from other cities. My intent . . . was to capture this distinctive quality and delineate it as 'an urban theory' or 'theory of civilization'. I did not set out to capture only the misery generated by the atomic bomb . . . Rather, I was attempting a kind of 'history of humankind'.[15]

Along with the images of twisted and burnt remnants collected by the Nagasaki Atomic Bomb Museum, Tōmatsu photographed victims of the bomb as well as locations throughout the city, adapting the more expressive approach that he had helped to pioneer. Some of the most poignant images are of damaged gravesites and sculpture from the Catholic cemetery in the Urakami neighbourhood (illus. 92).[16] The resulting book is a layered, multivalent portrait of Nagasaki that symbolically traced its modern history.[17]

Tōmatsu and other young photographers of the 1960s and '70s had come of age as Japan struggled to rebuild in the immediate post-war period. By the early 1960s Japan's recovery was complete. Tokyo was gearing up for the 1964 Olympics, a triumphant international event that testified to Japan's new place in the world.[18] But even though the physical landscape had been repaired, a sense of emotional dislocation continued

to linger. The rapid post-war recovery, prominent influence of American consumer culture and the complexities of US–Japan relations left many with a sense of cultural dissonance. This culminated in a series of dramatic political events: the demonstrations in 1960 associated with the passage of the US–Japan Security Treaty (abbreviated as *anpo* in Japanese), and the student riots of the late 1960s that protested against, among other things, Japan's tacit involvement in the Vietnam War through its hosting of US military bases. The graphic style then emerging from the Provoke artists lent itself particularly well to documenting the accompanying anxiety of urban life during this period.

The challenge to traditional photography presented by the Provoke artists resulted in an approach that was well suited to chronicling the energy and immediacy of the period.[19] Daidō Moriyama's photo-books including *Nippon gekijō shashinchō* (Japan: A Photo Theatre, 1968), *Shashin yo sayonara* (Farewell Photography, 1972), and *Kariudo* (The Hunter, 1972) are widely considered to be among the finest early examples of this new mode of expression.[20] Moriyama's *are-bure-boke-konpura* (rough, blurred, out-of-focus, contemporary) style consisted of street photography taken with a hand-held camera that deliberately ignored conventional aesthetic concerns. Scratches, spots, streaks, skewed compositions and images often taken so close up and/or blurred that the subjects are nearly unfathomable: all of these qualities imbued Moriyama's work with a befitting urgency (illus. 93). The city has since remained a key interest for Moriyama, particularly the Tokyo district of Shinjuku, known for both its sparkling high-rise office buildings and the somewhat seedier nightlife in the Kabukicho neighbourhood. It is the latter aspect that has fascinated Moriyama, who has described Shinjuku as having a mesmerizing, narcotic-like effect on him. His loose, formal manner, disjointed narrative sequences and the inky black printing of his photo-books aptly convey the suggestion of illicit nightlife activity and a hint of the desperation surrounding the sex trade. He continues to devote significant attention to Shinjuku, with recent books including *Shinjuku* (2002) and *Shinjuku 19XX-20XX* (2006).

Tōmatsu also turned his attention to Shinjuku in the late 1960s. As part of Vivo, he had been influential in developing a more personal

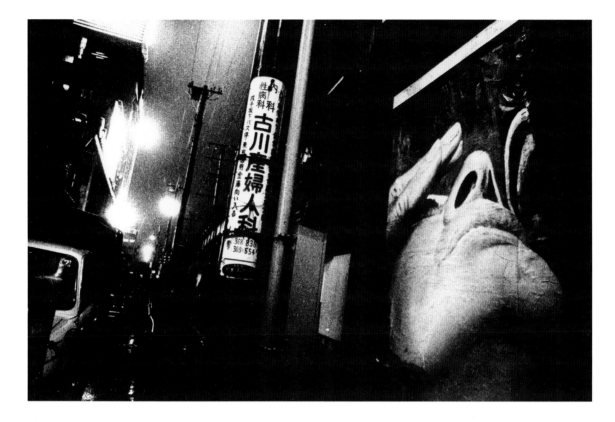

93 Daidō Moriyama, *Kariudo* (Hunter), 1972, black-and-white print.

and expressive mode of photography. He pushed this farther in *Oh! Shinjuku* (1969), adapting the rough and blurred Provoke style to capture the student riots of 1969. In one iconic photograph, Tōmatsu captured a solitary student in the act of violently throwing a projectile (illus. 95). The small figure, dressed in light clothing, is dramatically contrasted against a dark, blurred background, and seems to be arrested as if floating mid-air. The heightened contrast and blurred motion captures the danger of the act of protest, once again perfectly embodying the tension and anxiety of the era.

Another pioneering member of Provoke has been a prolific recorder of urban life for decades. Yutaka Takanashi has turned his attention to the city since the 1960s, using varied approaches to produce a broad body of work over the past half-century. Though involved in the Provoke

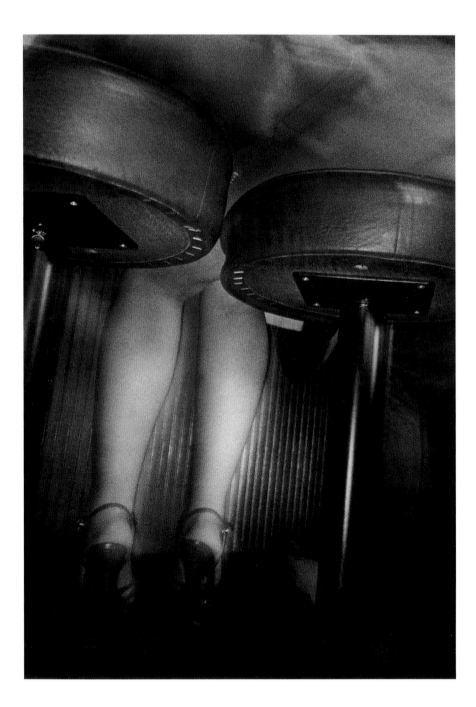

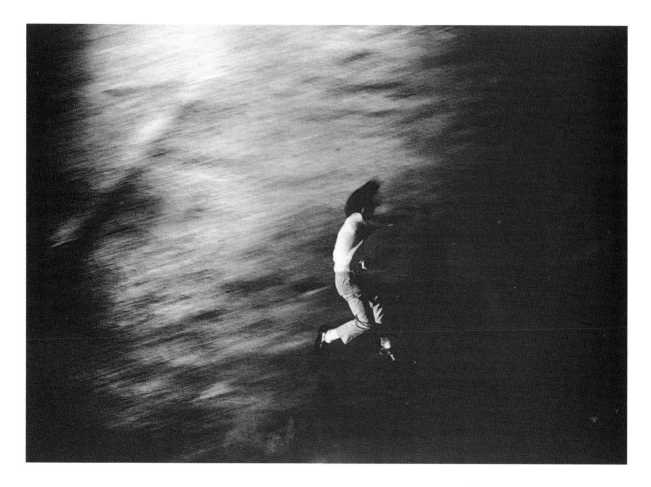

95 Shōmei Tōmatsu, 'Protest, Tokyo', from *Oh! Shinjuku* (1969), gelatin silver print.

94 Daidō Moriyama, *Shinjuku*, 2002, black-and-white print.

collective, his technique never devolved as far as Moriyama's, and he returned to a more conventionally straight aesthetic by the late 1970s. From early on, Takanashi emphasized his desire to combine two potentially opposing views, one as a 'hunter of images' who wants to capture the invisible, the other as a 'scrap picker' who is compelled to capture only the visible. Much of his work is a careful study of urban spaces that attempts to reconcile the two, actively seeking to expose what lies beneath the surface through extended formal attention. Thus his images are much more carefully controlled than the *are-bure-boke* approach of his contemporaries.

141

96 Yutaka Takanashi, 'Golden-Gai Street, Bar Mickey House', from *Text of the City: Shinjuku*, 1982, c-print.

Unlike Moriyama, Takanashi has also worked extensively with colour film. For two noteworthy studies, he employed colour and a 4 x 5 format camera with long exposure times (up to twenty minutes). For the 1970s series *Machi* (Town), Takanashi focused on the old Shitamachi area of Tokyo, capturing the interiors of traditional shops. *Text of the City: Shinjuku* (1980s) was inspired by Kevin Lynch's *The Image of the City* (1960), again using colour film to produce a series of images that frame unexpected snippets of Tokyo in a carefully studied manner. Both of these sequences are devoid of people. Takanashi described his interest in *Shinjuku* as focused on spatial elements, inspired by Lynch's theories of city planning; as he explained, the 'space axis' replaces the 'time axis' of the Provoke era.[21] The result could not be more diametrically opposed to Tōmatsu and Moriyama's images of the same neighbourhood.

By the 1970s and '80s colour photography was ubiquitous. Shigeo Gochō's street scenes in vibrant colour capture a happy, prosperous Japan in the midst of the economic expansion of the late 1970s and early 1980s. Shot from eye level and below (many seem to be chest- or

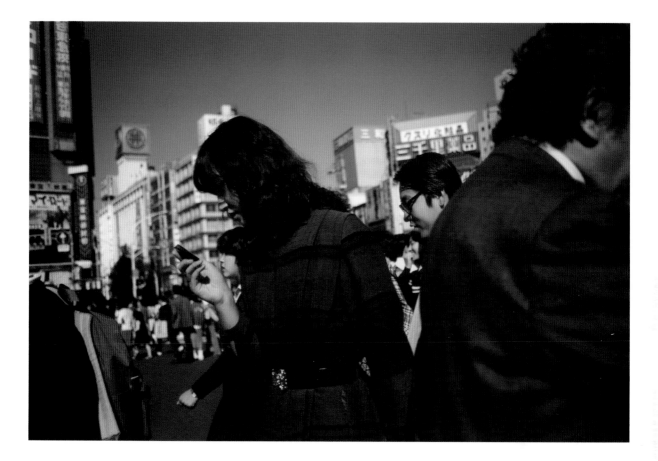

97 Shigeo Gochō, 'Untitled', from *Familiar Street Scenes*, 1978–80, chromogenic print.

waist-high views) without using the viewfinder, and employing both wide-angle and telescopic zoom lenses, Gochō's images of Tokyo convey the lively activity of shopping districts and areas with heavy foot traffic. People smile in his photographs, not at the photographer but rather as they are absorbed in their own daily lives. The cheerful effect is supported by the fact that the images frequently depict sunny days, with nary a cloud visible in the sky. But his intentions were somewhat darker; he claimed his interest was in 'the lingering of a mysterious shadow over the human existence'.[22] Because of the techniques used, the subjects rarely meet the gaze of the photographer, and the resulting images feel somewhat surreptitious. His desire to record a hint of darkness is perhaps

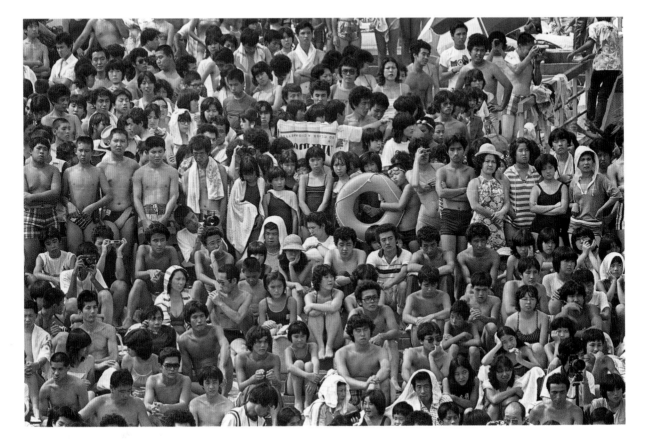

linked to a sense of personal melancholy: this was one of just four books that comprised the career of Gochō before he died prematurely at the age of 36.

The slightly unsettling liveliness in Gochō's images makes an interesting contrast to a series of views taken around the same time by Hiromi Tsuchida, another prolific recorder of city life (Tsuchida has produced a number of poignant works documenting the city of Hiroshima, for example). Tsuchida's images from the series *Suna wo kazoeru* (Counting Grains of Sand) document public places packed shoulder to shoulder with people relaxing during leisure time activities. A group of black-and-white photos of Japanese people waiting to swim stands out for the complete lack of chaos one might expect from such a scene (illus. 98). Rather, the

98 Hiromi Tsuchida, 'Pool, Oiso', from *Suna wo Kazoeru* (Counting Grains of Sand), 1981, gelatin silver print.

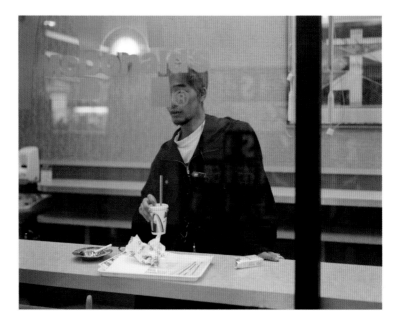

hundreds of people depicted stand quietly and orderly, in typical Japanese fashion, waiting for the all clear. The photo captures the essence of the disciplined Japanese group ethos that allows for peaceful coexistence in its high-density urban spaces.

Since the Japanese economic bubble of the late 1980s burst in 1990, a number of photographers have produced work that seems to implicitly question the meaning of a life dominated by contemporary urban consumer culture. Takashi Homma's photo-book *Tokyo Suburbia* drew widespread attention when it was published in 1998. The book is a collection of images depicting the outskirts of Tokyo, a city surrounded by an endless expanse that extends miles from the urban centre. This suburbia features thousands of high-rise apartment buildings and, further out, cookie-cutter fabricated houses. The photographs were published in a creative format on thick cardboard pages; with Homma's emphasis on vibrant, almost artificial, colour, the book calls to mind a children's storybook. But the people and sights included within are not particularly cheerful or lighthearted; rather they seem somewhat hollow and soulless. Homma's disaffected youth, standing nonchalantly in an empty car park

100 Keizō Kitajima, *Tokyo 1990*, c-print.

or staring blankly through the window of a fast-food restaurant, seem to embody once again the cultural malaise of the moment.[23]

Keizō Kitajima's urban photographs of 1990s Japan take a slightly different approach to convey a similar message. Kitajima photographed the grittier elements of New York City in the 1980s, and has often focused on cities over the course of his career. A series of images of city streets and buildings from the 1990s are shot from a low vantage point at street level and are lacking in any activity. Though one can sense a suggestion of human existence in the scattered bicycles and cars, the presence of life is virtually erased. With no flicker of movement among the tall buildings, the impression is of a city dominated by emptiness and sterility. As one critic has said:

> There is nothing positive in his celebration of the [buildings']
> aesthetic fascination. On the contrary, they are the focal points
> of that process of depersonalization, of globalization, of mental
> uniformity, that makes Japanese and Americans, Germans and
> Koreans not just similar, but the same.[24]

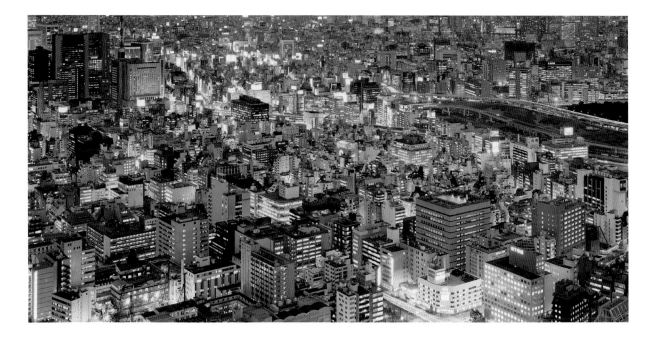

101 Naoya Hatakeyama, *Untitled #52810*, 1997, C-print mounted on aluminium.

Through Kitajima's images, Japan becomes visually linked to a universal malaise associated with urban culture.

Naoya Hatakeyama has produced a number of related works that also imply a critique of the metropolitan environment. His technique results in images that are technically and formally stunning, leaving the viewer with an impression of awe and wonder regarding large-scale city infrastructure. Hatakeyama is interested in the hidden underbelly of urban development, and has produced a broad range of images that focus on the processes and mechanisms of the urban space. His subjects include limestone quarries, city riverbeds, underground tunnels and sweeping aerial views of the labyrinth that is Tokyo; formats have included photo-books as well as large-scale prints (illus. 101). Hatakeyama's explanation of his attraction to limestone, his first extended project, reveals his seduction via these elements of infrastructure. His attention was drawn to Japan's limestone production once he learned that it was Japan's only substantial native raw material (the mountainous Japanese archipelago is notoriously lacking in natural resources). According to

Hatakeyama, some 200 million tonnes of limestone are produced in Japanese quarries per year to support urban renewal. This means, he says, that 'mines and cities are like the negatives and positives of a photograph'.[25] Though Hatakeyama's work speaks to the issue of environmental destruction and sustainability, its sheer beauty is visually compelling.[26]

Ryūji Miyamoto has also focused on the theme of destruction, though in a slightly more direct fashion than Hatakeyama. Miyamoto photographs contemporary ruins, whether they are a result of planned demolition to make way for new construction, or from natural disaster. He produced a number of striking images in Kobe following the 1995 earthquake that show the complete devastation caused by the 6.8 tremor (illus. 102). His reflections on the accelerated pace of urban building in the 1980s underscore the rapid pace of change in contemporary Japan:

> The harbor was completely occupied; the highways ran aboveground; the newly developed city center bristled with skyscrapers. At the same time, old buildings with extensions and many different facades,

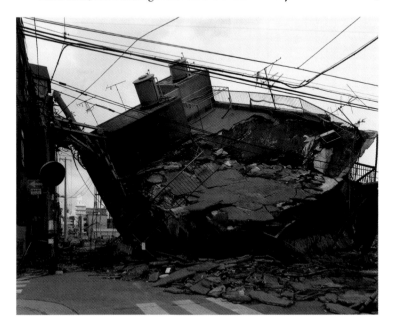

102 Ryūji Miyamoto, *Nagata-ku, Kobe*, 1995, gelatin silver print.

a large number of brick buildings downtown, erected at the beginning of the Shōwa period, and the sheet-copper-sided homes and apartment buildings were all torn up by their roots. Everywhere, the streets were different, made new, everything was subordinated to efficiency, and perverted into a colorless space. Inconvenient old buildings were replaced with astounding speed; there was no time for them even to fall into decay . . .[27]

Miyamoto is one of the few artists whose work has directly addressed the issue of homelessness in Japan, as he has also photographed the cardboard shacks that are found around Tokyo, which he sees as emblematic of the ruins of the modern city.[28] In the quest for never-ending 'progress', the human cost is too often overlooked.

While Hatakeyama and Miyamoto use formal components to onsider issues of profound subtlety, Kansai-based photographer Naoki Kajitani is somewhat more playful in his emphasis on form. His recent use of a digital format has lead him to focus on close-up details and stationary objects, which he frames as though the viewer is approaching them personally. He aims to represent local scenery, avoiding easily recognizable locations but capturing views that would be readily familiar to anyone who has lived in Japan, in an effort to show a generic yet authentic view of the country's urban environment. Kajitani gravitates towards seedier areas, capturing pachinko parlours or strip-club signs, which appeal to him for their bright colours and tacky quality. There is a strong element of humour underlying his work. He describes his intentions thus:

> There are two major roles in Kansai comedy culture: the *boke*, or dunce, and the *tsukkomi*, or wise ass. As a photographer, I sometimes assume the latter role, pointing at something in the city and saying 'hey, come on, someone has actually made this thing'?[29]

Many of his recent works have a strongly abstract formal emphasis on colour, and the focus on tightly composed details combined with the digital format creates a flattened spatial effect (illus. 103). Filled with

bright, gaudy, artificial hues and absent of human figures, the images
call to mind a theme park, an impression that seems to fit Kajitani's
lighthearted approach.

The work of Hiroh Kikai provides a suitable ending, as it returns the
theme of depicting the urban environment from the abstract formal level
to a more human one. Kikai has provided a deep and ongoing record
of a single neighbourhood in the city of Tokyo. For over three decades,
he has taken portraits of the various characters passing through Asakusa,
the same area that housed a popular amusement centre and the novelty
'Asakusa Twelve Storeys Building' a century ago (see illus. 84). Asakusa
never regained its status as a desirable entertainment district in the
wake of the Second World War, though it still draws tourists for Sensōji,
a popular Buddhist temple, and Nakamise, a street market selling various
tourist goods. Rather than focusing on the physical nature of this more
traditional neighbourhood, Kikai explores its 'personality' as revealed
through its residents and passersby.

Shot against a completely non-descript background (the bright red
walls of Sensōji temple, rendered unremarkable through his use of black-
and-white film), Kikai's images portray an eclectic selection of humanity,
capturing all manner of diverse and eccentric personalities that would be
found in any large city neighbourhood (illus. 104). For each figure, Kikai
includes a brief caption that summarizes the character of the sitter as
conveyed during their brief interaction. The portraits have a timeless
quality, aided by the fact that Kikai deliberately avoids choosing subjects
whose clothing might date the picture. As he returns to the same location,
he has had opportunities to photograph some of the individuals repeatedly
over the decades. Although viewers may be tempted to interpret his work
as an attempt at forming a portrait of the Japanese, Kikai presents a truly
broad humanist vision. As Christopher Phillips has noted, Kikai is both a
'humanist and a universalist, absorbed in speculation about the nature
of the human condition and the essentials of human character across the
ages'.[30] His subjects just happen to be Japanese. The universality embodied
in Kikai's work comes full circle back to the premise articulated in the
introduction: that rather than searching for some overarching distinctive
and unique Japanese quality to define it, photography in Japan is more

104 Hiroh Kikai, *A Tattoo Artist and his Son*, 2003, gelatin silver print.

aptly understood by considering the ways in which it intersects with a broad range of universally human concerns. This text has attempted to delineate three such themes that have played a formative role in both the history of photography and in the modern Japanese psyche.

References

Introduction: Photography in Japan

1 Naoyuki Kinoshita, 'The Early Years of Japanese Photography', in *The History of Japanese Photography*, ed. Anne Wilkes Tucker et al. (Houston and New Haven, CT, 2003), pp. 16–17.

2 Julia Adeney Thomas, 'Global Culture in Question: Contemporary Japanese Photography in America', in *Globalizing Japan: Ethnography of the Japanese Presence in Asia, Europe and America*, ed. Harumi Befu and Sylvie Guichard-Anguis (London and New York, 2001), pp. 133–7. Thomas also discusses Toshio Shibata, Yasumasa Morimura and Masao Yamamoto.

3 The terms modern and modernity are complex and often problematic. Here I use them, particularly in relation to the Meiji period, to refer broadly to the various cultural practices, progressive technologies and social changes that accompanied the opening up and industrialization of Japan from the second half of the nineteenth century on.

4 For the two most comprehensive English-language accounts of the history of photography in Japan, see John Dower, 'Ways of Seeing, Ways of Remembering: The Photography of Pre-war Japan', in Japan Photographers' Association, *A Century of Japanese Photography* (New York, 1980), pp. 3–19, and Tucker et al., ed., *The History of Japanese Photography*. In Japanese, see *Nihon shashin zenshū* (The Complete History of Japanese Photography), 12 vols (Tokyo, 1985–8); Japan Photographers Association, *Nihon gendai shashinshi 1945–95* (History of Contemporary Japanese Photography, 1945–95), (Tokyo, 2000); and Kōtarō Iizawa et al., *Nihon shashinshi gaisetsu* (Survey of the History of Japanese Photography) (Tokyo, 1999).

5 Alternative transliteration of his name is Shunnojō. See Takeshi Ozawa, *Nihon no shashinshi* (The History of Japanese Photography) (Tokyo, 1986), p. 13, for the document, and Junichi Himeno, 'Encounters with Foreign Photographers: The Introduction and Spread of Photography in Kyushu' in *Reflecting Truth: Japanese Photography in the Nineteenth Century*, ed. Nicole Coolidge Rousmaniere and Mikiko Hirayama (Leiden, 2004), pp. 18–29, on early photography.

6 Himeno, 'Encounters with Foreign Photographers', pp. 24–5.

7 On early Japanese photography, see Terry Bennett, *Photography in Japan, 1853–1912* (Tokyo and Rutland, VT, 2006) and *Shashin torai no koro* (The Advent of Photography in Japan) (Tokyo, 1997); on Yokohama photographs, see *Art and Artifice: Japanese Photographs of the Meiji Era*, exh. cat., Boston Museum of Fine Arts (Boston, MA, 2004).

8 For a discussion of photographic terminology, see Doris Croissant, 'In Quest of the Real: Portrayal and Photography in Japanese Painting Theory', in *Challenging Past and Present: The Metamorphosis of Nineteenth-century Japanese Art*, ed. Ellen Conant (Honolulu, HI, 2006), pp. 153–76.

9 On ambrotypes see Peter C. Jones, 'Japan's Best-Kept Secret: Japanese Ambrotype Portraits', *Aperture*, 138 (1995), pp. 75–8.

10 See Gordon Lewis, ed., *The History of the Japanese Camera* (Rochester, NY, and Tokyo, 1991) on the photo industry.

11 Burton arrived in Japan in 1887 to work at Tokyo Imperial University. He ended up living there (with the exception of a brief foray to Taiwan at the behest of the Japanese government) until his death in 1899. He was a member of the first two non-commercial photography groups, Nihon shashinkai (Japan Photography Group), founded in 1899, and Dai nihon shashin hinpyōkai (Greater Japan Photography Review Group), formed in 1893. The 1893 exhibition organized by the latter included works by members of the London Camera Club, including Peter Henry Emerson. See *Geijutsu shashin no keifu* (The Heritage of Art Photography in Japan), *Nihon shashin zenshū*, vol. II (Tokyo, 1986), especially pp. 145–7. Several of Burton's (English-language) articles on early Japanese photography have been republished in Terry Bennett, *Old Japanese Photographs: Collector's Data Guide* (London, 2006), pp. 46–55.

12 Modern Japanese historical periods are named after the ruling emperors. The Taishō period officially lasted from 1912 to 1926; other twentieth-century periods are Shōwa (1926–89) and Heisei (1989–present).

13 See Ryūichi Kaneko, *Modern Photography in Japan, 1915–1940* (San Francisco, CA, 2001), Christian A. Peterson, 'Pictorialism in Japan', in *Art Photography in Japan, 1920–1940* (New York, 2003), pp. 9–17, and Ryūichi Kaneko, 'Pictorial Photography in Japan', in *Truth Beauty: Pictorialism and the Photograph as Art, 1845–1945*, ed. Thomas Padon (Vancouver, 2008), pp. 81–4. For an overview of photography in the first half of the twentieth century, see *Nihon kindai shashin no seiritsu to tenkai* (The Founding and Development of Modern Photography in Japan) (Tokyo, 1995).

14 Comprehensive compilations of both photography groups and periodicals appear in Tucker, ed., *The History of Japanese Photography*.

15 See *Geijutsu shashin no keifu*. This book has chapters dedicated to key photography groups, demonstrating the far-reaching influence of various clubs.

16 Ryūichi Kaneko, 'Realism and Propaganda: The Photographer's Eye Trained on Society', in *The History of Japanese Photography*, ed. Tucker et al., p. 193.

17 See *Kindai shashin no gunzō* (The Modern Photography Movement in Japan), *Nihon shashin zenshū*, vol. III (Tokyo, 1986), pp. 167–70.

18 Hiraki Osam, 'Deciphering Japanese Postwar Photography', in
 Japan: A Self-portrait, Photographs 1945–1964, ed. Marc Feustel
 (Paris, 2004), pp. 22–3. Domon engaged in a very public debate
 about the role of photography in the pages of *Camera* magazine,
 where he judged the entries for a monthly contest of reader
 submissions.

19 Osam, 'Deciphering Japanese Postwar Photography', p. 42.

20 The Japanese photographers of the 1960s and '70s attracted critical
 global attention, leading to the Museum of Modern Art exhibition
 and related publication by John Szarkowski and Shoji Yamagishi,
 New Japanese Photography (New York, 1974). The work of Eikoh
 Hosoe, Shōmei Tōmatsu, Masahisa Fukase and Daidō Moriyama
 was also explored a decade later in Mark Holborn, *Black Sun: The
 Eyes of Four* (New York, 1986).

21 See Ivan Vartanian and Ryūichi Kaneko, *Japanese Photobooks of
 the 1960s and '70s* (New York, 2009) and Martin Parr and Gerry
 Badger, *The Photobook: A History*, vol. I (London, 2004), pp. 266–311.

22 *Barakei* was published in several versions. The original 1963
 publication was translated as 'Death by Roses', but Hosoe revised
 the translation to 'Ordeal by Roses' for the 1971 edition.

23 On Suzuki and Takano, see *Kiss in the Dark: Contemporary Japanese
 Photography* (Tokyo, 2002), pp. v–vii.

24 Dana Friis-Hansen has written about this in 'Internationalization,
 Individualism and the Institutionalization of Photography', in *The
 History of Japanese Photography*, ed. Tucker et al., pp. 260–79.

25 See Mio Wakita, 'Selling Japan: Kusakabe Kimbei's Images of
 Japanese Women', *History of Photography*, XXXIII/2 (2009),
 pp. 209–23.

26 *Modern Photography: Iwata Nakayama Retrospective*, exh. cat. Ashiya
 City Museum of Art, Ashiya (1996), pp. 11–16.

27 Two of Beato's albums may be viewed on the Massachusetts
 Institute of Technology's 'Visualizing Cultures' website, at http://
 ocw.mit.edu/ans7870/21f/21f.027/beato_places/index.html.

one: Representation and Identity

1 See Mikiko Hirayama, 'The Emperor's New Clothes: Japanese
 Visuality and Imperial Portrait Photography', *History of
 Photography*, XXXIII/2 (2009), pp. 165–84; Morris Low, *Japan
 on Display: Photography and the Emperor* (London and New York,
 2006), pp. 9–14; and Donald Keene, 'Portraits of the Emperor
 Meiji', *Impressions*, 21 (1999), pp. 17–29. Uchida's portraits were
 not technically the first taken of the emperor: the Austrian Baron
 Raimund von Stillfried-Ratenicz surreptitiously photographed
 the emperor during a New Year's outing in 1872, just weeks before
 Uchida was commissioned to take the official portrait. See Terry
 Bennett, *Photography in Japan, 1853–1912* (Tokyo and Rutland, VT,
 2006), pp. 137–8.

2 See T. Fujitani, *Splendid Monarchy: Power and Pageantry in Modern
 Japan* (Berkeley, CA, 1996), and Hirayama, 'The Emperor's New
 Clothes'. Note that the government tightly regulated distribution
 of the imperial photograph throughout the country.

3 On Felice Beato, see *F. Beato bakumatsu nihon shashinshū* (Felice
 Beato Bakumatsu Japan Photo Album) (Yokohama, 1987) and
 Takio Saitō, *Bakumatsu Meiji Yokohama shashinkan monogatari*
 (The Story of Yokohama Bakumatsu-Meiji Photography Studios)
 (Tokyo, 2004), pp. 56–105.

4 For an example, see *Once Upon a Time: Visions of Old Japan from
 the Photos of Beato and Stillfried and the Words of Pierre Loti* (New
 York, 1986). Recent publications that present a more nuanced
 view of Yokohama photographs include Isobel Crombie, *Shashin:
 Nineteenth-century Japanese Studio Photography*, exh. cat., National
 Gallery of Victoria, Melbourne (2004) and Sebastian Dobson et
 al., *Art and Artifice: Japanese Photographs of the Meiji Era*, exh. cat.,
 Museum of Fine Arts, Boston (2004).

5 Naoyuki Kinoshita, *Shashin garon: shashin to kaiga no kekkon*
 (On Photographic Pictures: The Marriage of Photography
 and Painting) (Tokyo, 1996), pp. 21–2. Kinoshita reproduces
 a broadsheet from 1877 ranking Tokyo photographers.

6 *Utsusareta kokuhō: Nihon ni okeru bunkazai shashin no keifu* (Image
 and Essence: A Genealogy of Japanese Photographers' Views of
 National Treasures) (Tokyo, 2000), pp. 10–40.

7 Fenollosa and Okakura played a formative role in preserving
 Japanese cultural heritage within Japan. They also helped to bring
 traditional Japanese art to a Western audience by building the
 collections of Japanese art at the Museum of Fine Arts, Boston.

8 See *Artist Photograph Kenzō Tamoto: Photographer's Gallery Press*,
 8 (Tokyo, 2009), pp. 221–33.

9 David R. Odo, 'Expeditionary Photographs of the Ogasawara
 Islands, 1875–76', *History of Photography*, XXXIII/2 (2009),
 pp. 185–208. See page 196 for the monument photo. Odo considers
 Matsuzaki images found in three different collections; the group
 that made its way into the Tokyo National Museum and the
 National Archives of Japan is most relevant to the discussion here.

10 On the Ainu and their connection to the Japanese state, see David
 L. Howell, *Geographies of Identity in Nineteenth-century Japan*,
 (Berkeley, CA, 2005), especially pp. 172–96.

11 *Artist Photograph Kenzō Tamoto: Photographer's Gallery Press 8*, p. 231.
 Matsusaburō Yokoyama's photographs of historic temples and
 treasures of the Kinki region, commissioned by the government
 in 1872, were also shown at the Vienna World Exposition.

12 Ka F. Wong, 'Entanglements of Ethnographic Images: Torii Ryūzō's
 Photographic Record of Taiwan Aborigines (1896–1900)', *Japanese
 Studies*, XXI/3 (2004), pp. 283–99.

13 Naoyuki Kinoshita, 'Portraying the War Dead: Photography as
 a Medium for Memorial Portraiture', in *Reflecting Truth: Japanese
 Photography in the Nineteenth Century*, ed. Nicole Rousmaniere and

Mikiko Hirayama (Leiden, 2004), p. 93.

14 'Nihon dai ichi bijin no shashin wo boshsu', (Searching for Photos of Japan's Top Beauty), *Jiji shimpō* (Current Events), 15 September 1907, reprinted in Kenji Ozawa, *Koshashin de miru bakumatsu Meiji no bijin zukan* (Seen Through Old Photos: Bakumatsu Meiji Picture Book of Beauties) (Tokyo, 2001), pp. 108–9.

15 Karen Fraser, 'Beauty Battle: Politics and Portraiture in Late Meiji Japan (1868–1912)', in *In the Name of Woman: Modernity, Commerce and Colonialism in East Asia*, ed. Aida Yuen Wong (Hong Kong, 2011). On the role of women in representing the Japanese state, see Miya Lippit, 'Figures of Beauty: Aesthetics and the Beautiful Woman in Meiji Japan', New Haven, PhD thesis, Yale University, 2001.

16 Christine Guth, 'Charles Longfellow and Okakura Kakuzō: Cultural Cross-Dressing in the Colonial Context', *positions*, VIII/3 (2000), p. 607.

17 See Guth, 'Charles Longfellow and Okakura Kakuzō', pp. 605–36. More than a century later, playing dress-up for the camera remains a popular form of self-expression. Contemporary speciality studios, for example, offer the opportunity to be photographed dressed as *maiko* or samurai.

18 On Japanese-American photography, see Dennis Reed, *Japanese Photography in America, 1920–1940* (Los Angeles, CA, 1985), 'Japanese American Pictorialist Photography' in *Asian American Modern Art: Shifting Currents, 1900–1970*, ed. Daniell Cornell and Mark Dean Johnson (San Francisco, CA, 2008), pp. 64–73, and Dennis Reed, 'The Wind Came from the East: Asian American Photography, 1850–1965', in *Asian American Art: A History, 1850–1970*, ed. Gordon H. Chang, Mark Dean Johnson and Paul J. Karlstrom (Stanford, CA, 2008), pp. 141–67.

19 See *Geijutsu shashin no keifu* (The Heritage of Art Photography in Japan), *Nihon shashin zenshū*, vol. II (Tokyo, 1986), pp. 33–40, 153–4. Shinzō Fukuhara published a number of collections, notably *Paris et la Seine* in 1922, based on images he had taken while in Europe a decade earlier. Rosō's work was not published in his lifetime, although he was an influential figure in early Japanese Modernism.

20 See Kōtaro Iizawa, ed., *Fukuhara Shinzō to Fukuhara Rosō* (Tokyo, 1999).

21 Philip Charrier, 'Nojima Yasuzō's Primitivist Eye: "Nude" and "Natural" in Early Japanese Art Photography', *Japanese Studies*, XXVI/1 (2006), pp. 47–68. See also *Nojima Yasuzō to sono shūhen: Nihon kindai shashin to kaiga no hitotsu danmen* (Yasuzo Nojima and Contemporaries: One Aspect of Modern Japanese Photography and Paintings) (Kyoto, 1991).

22 Doris Croissant, 'Icons of Femininity: Japanese National Painting and the Paradox of Modernity', in *Gender and Power in the Japanese Visual Field*, ed. Joshua S. Mostow, Norman Bryson and Maribeth Graybill (Honolulu, HI, 2003), pp. 119–39.

23 See Kōtaro Iizawa, ed., *Fuchikami Hakuyō to Manshū shashin sakka kyōkai* (Fuchikami Hakuyō and the Photographers in Manchuria) (Tokyo, 1999). A comprehensive overview of key groups and publications can be found in the appendices in Anne Wilkes Tucker et al., ed., *The History of Japanese Photography* (Houston, TX, and New Haven, CT, 2003).

24 See David C. Earhart, *Certain Victory: Images of World War II in the Japanese Media* (Armonk, NY, and London, 2008), pp. 309–25. An issue of *Shashin bunka* (Photographic Culture) documented the construction of the poster.

25 See Gennifer Weisenfeld, 'Touring Japan-as-Museum: NIPPON and Other Japanese Imperialist Travelogues', *positions*, VIII/3 (2000), pp. 774–81. Weisenfeld provides a particularly provocative analysis of NIPPON.

26 Facsimile editions of both NIPPON and *Front* have been republished in recent years.

27 Harry Harootunian, 'Hirohito Redux', *Critical Asian Studies*, XXXIII/4 (2001), p. 621.

28 Herbert P. Bix, 'Inventing the "Symbol Monarchy" in Japan, 1945–52', *Journal of Japanese Studies*, XXI/2 (1995), pp. 324–5.

29 Ibid., p. 324.

30 Ibid., p. 325.

31 On the publication of photographs of the emperor leading up to and during the war, see Earhart, *Certain Victory*, pp. 11–35.

32 See Kōtaro Iizawa, ed., *Yamahata Yōsuke* (Tokyo, 1998).

33 The role of this photograph and others in shaping public perceptions of the emperor is addressed in Julia Adeney Thomas, 'The Unreciprocated Gaze: Emperors and Photography', in *The Emperors of Modern Japan*, ed. Ben-Ami Shillony (Leiden, 2008), pp. 185–210.

34 Jonathan M. Reynolds, 'Ise Shrine and a Modernist Construction of Japanese Tradition', *Art Bulletin*, LXXXIII/2 (2001), pp. 316–41.

35 André Sorensen, *The Making of Urban Japan: Cities and Planning from Edo to the Twenty-First Century* (London, 2002), p. 172.

36 For a survey of photographs of traditional Japanese culture, see *Minzoku to dentō* (Culture and Tradition), *Nihon shashin zenshū*, vol. IX (Tokyo, 1987).

37 Fukase's work on other family relationships included the series *Kazoku* (Family), which he stopped in the late 1980s after his father died, and the book *Chichi no Kioku* (Memories of Father) (Tokyo, 1991), which chronicled his father's life, old age and death. He is perhaps best known for *Karasu* (Tokyo, 1986, published in English as *The Solitude of Ravens* in 1991), a series of bleak images of crows that are often interpreted as portraying his fragile and depressed mental state post-divorce. Fukase's story has a tragic ending, as he has remained in a coma since an alcohol-induced fall in 1992.

38 Araki is perhaps the most prolific Japanese photographer ever. He is best known in the West nowadays for his sexually explicit bondage-themed photographs, but his work has covered nearly

every conceivable topic, from urban neighbourhoods to cats to food. For a broad selection of Araki's work, see Akiko Miki, Yoshiko Isshiki and Tomoko Sato, *Araki: Self, Life, Death* (London, 2005) and Nobuyoshi Araki, *Araki by Araki: The Photographer's Personal Selection* (Tokyo, 2003).

39 Jonathan Wallis, 'The Paradox of Mariko Mori's Women in Post-Bubble Japan: Office Ladies, Schoolgirls and Video Vixens', *Women's Art Journal*, XXIX/1 (2008), pp. 3–12.

40 For a recent interview with Yanagi, see 'Miwa Yanagi: A Supremely Comfortable Place to Be', in Christopher Phillips and Noriko Fuku, *Heavy Light: Recent Photography and Video from Japan* (New York, 2008), pp. 213–21.

41 'Tomoko Sawada: Self-portraiture is Fundamentally about Disguise', in Phillips and Fuku, *Heavy Light*, p. 173.

42 When this work was exhibited in venues throughout Japan, viewers were asked to indicate their favourite image. There were striking differences in the image chosen for first place in various cities, an interesting twist to think about in relation to the issue of regional identity. See Phillips and Fuku, *Heavy Light*, p. 176.

43 'Midori Komatsubara: A Rather Girlie Double Standard', in Phillips and Fuku, *Heavy Light*, p. 112.

44 See Yasumasa Morimura, *Daughter of Art History: Photographs by Yasumasa Morimura* (New York, 2003).

two: Visions of War

1 For an overview of war photography, see *Sensō no kiroku* (War Photography), *Nihon shashin zenshū*, vol. IV (Tokyo, 1987).

2 On Beato, see Terry Bennett, *Photography in Japan, 1853–1912* (Tokyo and Rutland, VT, 2006), pp. 86–97. Yoshikatsu Tokugawa was probably the first Japanese photographer to carry a camera into battle, which he did during another skirmish with the Chōshū clan in 1863. Unfortunately he made no images. See Sebastian Dobson, 'Reflections of Conflict: Japanese Photographers and the Russo-Japanese War', in *A Much Recorded War: The Russo-Japanese War in History and Imagery*, exh. cat., Museum of Fine Arts, Boston (2005), p. 54.

3 The traditional class structure positioning the samurai class at the top of the social hierarchy had been dismantled early in the Meiji period. Rather than relying on soldiers born into the military class, the new Meiji government began a policy of universal conscription in 1873, requiring all men to serve in the military.

4 Tomishige took a series of photos of Kumamoto castle in 1871, prior to its destruction in the Satsuma War. These were used to help reconstruct the castle nearly a century later.

5 On photographs of this war, see Hiroo Ishikawa, 'Seinan sensō no shashin' (Photographs of the Seinan War) in *Shashin: Meiji no sensō* (Photography: Meiji War), ed. Kenji Ozawa (Tokyo, 2001), pp. 11–37.

6 Dobson, 'Reflections of Conflict', pp. 55–61.

7 See ibid., pp. 55–61, and Ozawa, *Shashin: Meiji no sensō*, pp. 40–41 and 70–71. Note that images produced by both units were not clearly attributable to individual photographers.

8 Dobson, 'Reflections of Conflict', p. 58.

9 Giles Richter, 'Entrepreneurship and Culture: The Hakubunkan Publishing Empire in Meiji Japan', in *New Directions in the Study of Meiji Japan*, ed. Helen Hardacre and Adam L. Kern (Leiden and New York, 1997), p. 597.

10 Dobson, 'Reflections of Conflict', pp. 62, 67.

11 Ibid., pp. 62, 67, and Ozawa, *Shashin: Meiji no sensō*, pp. 126–32.

12 'A Letter from Japan', 1 August 1904, quoted in F. G. Notehelfer, 'Burton Holmes, the Camera and the Russo-Japanese War', *Asian Art*, VI/1 (1993), pp. 51–9.

13 On postcards of the Russo-Japanese War, see Anne Morse et al., *Art of the Japanese Postcard*, exh. cat., Museum of Fine Arts, Boston (2004), especially pp. 77–103.

14 See Ryūichi Kaneko, 'Realism and Propaganda: The Photographer's Eye Trained on Society', in *The History of Japanese Photography*, ed. Anne Wilkes Tucker et al. (Houston, TX, 2003), pp. 186–93 for an overview of realism and propaganda in the 1930s and '40s.

15 David C. Earhart, *Certain Victory: Images of World War II in the Japanese Media* (Armonk, NY, and London, 2008), p. xi.

16 Karen Higa and Tim B. Wride, 'Manzanar Inside and Out: Photo Documentation of the Japanese Wartime Incarceration', in *Reading California: Art, Image and Identity*, ed. Stephanie Barron, Sheri Bernstein and Ilene Susan Fort (Los Angeles and Berkeley, CA, 2000), pp. 315–37. Dorothea Lange and Ansel Adams both documented the internment camps as well. See also Judith Fryer Davidov, '"The Color of My Skin, the Shape of My Eyes": Photographs of the Japanese-American Internment by Dorothea Lange, Ansel Adams and Toyo Miyatake', *The Yale Journal of Criticism*, IX/2 (1999), pp. 223–44, and Jasmine Alinder, *Moving Images: Photography and the Japanese American Incarceration* (Urbana and Chicago, IL, 2009).

17 On Yamahata, see Rupert Jenkins, ed., *Nagasaki Journey: The Photographs of Yosuke Yamahata, August 10, 1945* (San Francisco, CA, 1995). For a provocative discussion of these images, including their role in the 'Family of Man' exhibit, see Tessa Morris Suzuki, 'Shadow on the Lens: Memory as Photograph', in *The Past Within Us: Media, Memory, History* (London and New York, 2005), pp. 71–119, and Christopher Beaver, 'Notes on Nagasaki Journey', *positions*, V/3 (1997), pp. 673–85.

18 Tōmatsu recounted his involvement with the project in Linda Hoagland, 'Interview with Tomatsu Shomei', *positions*, V/3 (1997), pp. 835–62.

19 *Hiroshima, Hiroshima Nagasaki Document 1961* and *Chizu* are all discussed in Martin Parr and Gerry Badger, *The Photobook: A History*, vol. I (London, 2004), pp. 267–87.

20 Due to the overwhelming military presence, Okinawan culture was dominated by Americana. But when Tōmatsu travelled to rural villages he was surprised to find that they were far more traditional than he expected. He started to use colour to photograph the tropical environment, and eventually concluded that his use of colour was directly tied to his feelings about the US: 'What I realize is that my obsession with America is disappearing. America sometimes becomes visible in the black-and-white pictures, but the shadow of America is not obvious in the color prints . . . I achieved de-Americanization through the experiences I had in Okinawa while changing my photographic approach from monochrome to color.' Shōmei Tōmatsu, 'Toward a Chaotic Sea', in *Traces – 50 Years of Tomatsu's Work* (Tokyo, 1999); reprinted in *Setting Sun: Writings by Japanese Photographers*, ed. Ivan Vartanian, Akihiro Hatanaka and Yutaka Kambayashi (New York, 2006), pp. 30–33.

three: Picturing the City

1 Elizabeth Siegel, 'An Interview with Tokihiro Sato', in *Photo-Respiration: Tokihiro Sato Photographs* (Chicago, IL, 2005), p. 31.

2 See Peter Bacon Hales, *Silver Cities: Photographing American Urbanization, 1839–1939*, revised and expanded edition (Albuquerque, NM, 2005) for an exemplary study of the relationship between photography and urbanization.

3 Conventional wisdom for much of the twentieth century held that the first two Japanese-operated photography studios both opened in 1862 (Hikoma Ueno's in Nagasaki and Renjō Shimooka's in Yokohama). Both locations drew a primarily foreign clientele who could afford the still expensive product. Recent research has revealed that Gyokusen Ukai opened an earlier studio in Tokyo in 1860 or 1861. Notably, foreigners were not free to travel to Tokyo at this time, thus Ukai would have had a Japanese clientele. See Terry Bennett, *Photography in Japan 1853–1912* (Rutland, VT, and Tokyo, 2006), pp. 60–61, and Saitō Takio, *Bakumatsu Meiji Yokohama Shashinkan Monogatari* (The Story of Yokohama Bakumatsu Meiji Photography Studios) (Tokyo, 2004), pp. 16–33.

4 André Sorensen, *The Making of Urban Japan: Cities and Planning from Edo to the Twenty-first Century* (London, 2002), p. 9.

5 For a wonderful exploration of Tokyo, see Mildred Friedman, ed., *Tokyo: Form and Spirit*, exh. cat., Walker Art Center, Minneapolis (New York, 1986).

6 On the use of Western-style architecture by the Meiji state, see William H. Coaldrake, *Architecture and Authority in Japan* (London and New York, 1996), pp. 208–50, Toshio Watanabe, 'Josiah Conder's Rokumeikan: Architecture and National Representation in Meiji Japan', *Art Journal*, VXV/5 (1996), pp. 21–7, and Alice Y. Tseng, *The Imperial Museums of Meiji Japan: Architecture and the Art of the Nation* (Seattle, WA, 2008).

7 Shōichi Inoue, *Bijin kontesuto hyakunenshi: geigi no jidai kara bishojo made* (One Hundred Years of Beauty Contests: From Geisha to Beautiful Girls) (Tokyo, 1992), pp. 41–2.

8 See Jackie Menzies, ed., *Modern Boy Modern Girl: Modernity in Japanese Art, 1910–1935*, exh. cat., Art Gallery of New South Wales, Sydney (1998), especially Ajioke Chiaki, 'The Lure of the City', pp. 29–51.

9 This photo-essay appeared in *Chūō Koron* (Central Review), a literary journal (October, 1931).

10 See *Kindai shashin no gunzō* (The Modern Photography Movement in Japan), *Nihon shashin zenshū*, vol. III (Tokyo, 1986).

11 See *Kobe modanizumu no kōsai: Nakayama Iwata* (Luminous Colours of Kobe Modernism: Iwata Nakayama), exh. cat., Ashiya City Museum of Art, Ashiya (1996) and *Modern Photography: Iwata Nakayama Retrospective*, exh. cat., Ashiya City Museum of Art (1996).

12 Ihee Kimura, 'From Postwar Japan to Travels West', in *Kimura Ihee*, trans. Ivan Vartanian (Tokyo, 1956), reprinted in *Setting Sun: Writings by Japanese Photographers* (New York, 2006), pp. 89–91.

13 See Marc Feustel, ed., *Japan: A Self-Portrait, Photographs, 1945–1964* (Paris, 2004) for an overview of photography in the immediate postwar period.

14 On postwar photo-books, see Martin Parr and Gerry Badger, *The Photobook: A History*, vol. I (London, 2004), pp. 267–87; on photo-books of the 1960s and '70s see Ivan Vartanian and Kaneko Ryūichi, *Japanese Photobooks of the 1960s and '70s* (New York, 2009).

15 Linda Hoagland, 'Interview with Tomatsu Shomei', *positions*, V/3 (1997), p. 846.

16 Though Japan has a minimal Christian presence today, the Catholic heritage in Nagasaki is a direct result of its brief interaction with the West in the sixteenth century prior to the advent of Edo period isolationism. The Catholic cemetery is considered by many to be especially significant because it symbolizes this initial contact as well as Japan's destruction at the hands of the West.

17 On Tōmatsu, see Leo Rubinfien, Sandra Phillips and John W. Dower, *Shomei Tomatsu: Skin of the Nation* (San Francisco, CA, 2004).

18 For a summary of this period and its related artistic activities, see Reiko Tomii, 'Tokyo 1967–1973', in *Century City: Art and Culture in the Modern Metropolis*, ed. Iwona Blazwick (London, 2001), pp. 198–223.

19 Notably, it is the work of Tōmatsu, Moriyama and others during this period that first attracted international attention to the field of Japanese photography, leading John Szarkowski and Shoji Yamagishi to organize the groundbreaking exhibition 'New Japanese Photography' at the Museum of Modern Art in New York in 1974.

20 For an English language overview of Moriyama's work, see Sandra S. Phillips, Alexandra Munroe and Daido Moriyama, *Daido Moriyama: Stray Dog* (San Francisco, CA, 1999).

21 Rei Masuda and Shogo Otani, eds, *Takanashi Yutaka: Hikari no Fieldnote* (Yutaka Takanashi: Field Notes of Light) (Tokyo, 2009), pp. 144–6.

22 Rei Masuda, ed., *Gochō Shigeo: A Retrospective* (Tokyo, 2003), p. 60.

23 See Shino Kuraishi, 'The Membrane of Cities and Architecture: Takashi Homma's Photographs', *Camera Austria International*, 77 (2002), pp. 4–15 and Ivan Vartanian, *Takashi Homma: Tokyo, A Collection of Photographs* (New York, 2008).

24 Filippo Maggia, *Instant City* (Milan, 2001), p. 24.

25 Naoya Hatakeyama, 'Lime Works', in Vartanian, *Setting Sun*, p. 111.

26 *Naoya Hatakeyama* (Ostfildern-Ruit, 2002), and 'Naoya Hatakeyama: Cross-Examined by the Photographs I Take', in Christopher Phillips and Noriko Fuku, *Heavy Light: Recent Photography and Video from Japan* (New York, 2008), pp. 31–53.

27 Ryuji Miyamoto, 'Temporary Ruins', in Vartanian, *Setting Sun*, p. 51.

28 See *Ryuji Miyamoto* (Göttingen, 1999) and *Liquid Crystal Futures: Contemporary Japanese Photography* (Edinburgh, 1994).

29 'Naoki Kujitani: This is Japan', in Phillips and Fuku, *Heavy Light*, pp. 59–62.

30 *Hiroh Kikai: Asakusa Portraits* (New York, 2008), p. 8. See also *Tokyo Dream Tales* (Tokyo, 2007).

Select Bibliography

Alinder, Jasmine, *Moving Images: Photography and the Japanese American Incarceration* (Urbana, IL, 2009)

Araki, Nobuyoshi, *Araki by Araki* (Tokyo, 2003)

Art and Artifice: Japanese Photographs of the Meiji Era: Selections from the Jean S. and Frederic A. Sharf Collection at the Museum of Fine Arts, Boston, exh. cat., Museum of Fine Arts, Boston (2004)

Artist Photograph Tamoto Kenzō: Photographer's Gallery Press 8 (Tokyo, 2009)

Badger, Gerry, and Martin Parr, *The Photobook: A History*, vol. I (London, 2004)

Beaver, Christopher, 'Notes on Nagasaki Journey', *positions*, v/3 (1997), pp. 673–85

Bennett, Terry, *Old Japanese Photographs: Collector's Data Guide* (London, 2006)

——, *Photography in Japan, 1853–1912* (Tokyo and Rutland, VT, 2006)

Bix, Herbert P., 'Inventing the "Symbol Monarchy in Japan, 1945–52', *Journal of Japanese Studies*, XXI/2 (1995), pp. 324–5

Blazwick, Iwona, ed., *Century City: Art and Culture in the Modern Metropolis* (London, 2001)

Bryson, Norman, 'Morimura: 3 Readings', in *Morimura Yasumasa – The Sickness as Beauty: Self-portrait as Actress*, exh. cat., Yokohama Museum of Art, Yokohama (1996), pp. 163–7

——, Maribeth Graybill and Joshua S. Mostow, eds, *Gender and Power in the Japanese Visual Field* (Honolulu, 2003)

Charrier, Philip, 'Nojima Yasuzo's Primitivist Eye: "Nude" and "Natural" in Early Japanese Art Photography', *Japanese Studies*, XXVI/1 (2006), pp. 47–68

Cheung, Sidney C. H., 'Photographing the Ainu and the Emperor: Modernity in Meiji Japan', *The CUHK Journal of Humanities*, 1 (1997), pp. 252–68

Coaldrake, William H., *Architecture and Authority in Japan* (London and New York, 1996)

Conant, Ellen, *Challenging Past and Present: The Metamorphosis of Nineteenth-century Japanese Art* (Honolulu, HI, 2006)

Cornell, Daniel, and Mark Dean Johnson, eds, *Asian American Modern Art: Shifting Currents, 1900–1970* (San Francisco, CA, 2008)

Crombie, Isobel, *Shashin: Nineteenth-century Japanese Studio Photography*, exh. cat., National Gallery of Victoria (2004)

Davidov, Judith Fryer, '"The Color of My Skin, the Shape of My Eyes": Photographs of the Japanese-American Internment by Dorothea Lange, Ansel Adams and Toyo Miyatake', *The Yale Journal of Criticism*, IX/2 (1996), pp. 223–44

Dobson, Sebastian, 'Reflections of Conflict: Japanese Photographers and the Russo-Japanese War', in *A Much Recorded War: The Russo-Japanese War in History and Imagery*, exh. cat., Museum of Fine Arts, Boston (2005), pp. 52–83

Documentary no jidai: Natori Yōnosuke, Kimura Ihee, Domon Ken, Miki Jun no Shashin kara (The Documentary Age: Photographs by Natori Yōnosuke, Kimura Ihee, Domon Ken, Miki Jun) (Tokyo, 2001)

Dower, John, 'Ways of Seeing, Ways of Remembering: The Photography of Prewar Japan', in *A Century of Japanese Photography* (New York, 1980), pp. 3–20

——, W., Sandra S. Phillips and Leo Rubinfien, *Shomei Tomatsu: Skin of the Nation*, exh. cat., San Francisco Museum of Modern Art (San Francisco and New Haven, CT, 2004)

Earhart, David C., *Certain Victory: Images of World War II in the Japanese Media* (Armonk, NY, and London, 2008)

Edel, Chantal, 'Introduction', and Linda Coverdale, trans., *Once Upon a Time: Visions of Old Japan* (New York, 1986)

F. Beato Bakumatsu Nihon Shashinshū (Felice Beato Bakumatsu Japan Photo Album) (Yokohama, 1987)

Feustel, Marc, ed., *Japan: A Self-portrait, Photographs 1945–1964* (Paris, 2004)

Fraser, Karen, 'Beauty Battle: Politics and Portraiture in Late Meiji Japan (1868–1912)', in *In the Name of Woman: Modernity, Commerce and Colonialism in East Asia*, ed. Aida Yuen Wong (Hong Kong, 2011)

Friedman, Mildred, ed., *Tokyo: Form and Spirit*, exh. cat., Walker Art Center, Minneapolis (New York, 1986)

Fujitani, T., *Splendid Monarchy: Power and Pageantry in Modern Japan* (Berkeley, CA, 1996)

Fuku, Noriko and Christopher Phillips, *Heavy Light: Recent Photography and Video from Japan*, exh. cat., International Center of Photography, New York (2008)

Gartlan, Luke, 'Types or Costumes? Reframing Early Yokohama Photography', *Visual Resources*, XXII/3 (2006), pp. 239–63

Guth, Christine, 'Charles Longfellow and Okakuro Kakuzō: Cultural Cross-Dressing in the Colonial Context', *positions*, VIII/3 (2000), pp. 605–36

Hales, Peter Bacon, *Silver Cities: Photographing American Urbanization, 1839–1939*, revd and expanded edn (Albuquerque, NM, 2005)

Hardacre, Helen, and Adam L. Kern, eds, *New Directions in the Study of Meiji Japan* (Leiden and New York, 1997)

Harootunian, Harry, 'Hirohito Redux', *Critical Asian Studies*, XXXIII/4 (2001)

Higa, Karen, and Tim B. Wride, 'Manzanar Inside and Out: Photo Documentation of the Japanese Wartime Incarceration', in *Reading California: Art, Image and Identity*, ed. Stephanie Barron, Sheri Bernstein and Ilene Susan Fort (Los Angeles and Berkeley, CA, 2000)

Hight, Eleanor M., 'The Many Lives of Beato's "Beauties"', in *Colonialist Photography: Imagining Race and Place*, ed. Eleanor M. Hight and Gary D. Sampson (London, 2002), pp. 126–58

Himeno, Junichi, 'Encounters with Foreign Photographers: The Introduction and Spread of Photography in Kyushu', in *Reflecting Truth*, ed. Nicole Coolidge Rousmaniere and Mikiko Hirayama (Leiden, 2004)

Hirayama, Mikiko, 'The Emperor's New Clothes: Japanese Visuality and Imperial Portrait Photography', *History of Photography*, XXXIII/2 (2009), pp. 165–84

Hoaglund, Linda, 'Interview with Tōmatsu Shōmei', *positions*, V/3 (1997), pp. 835–62

Hockley, Allen, 'Cameras, Photographs and Photography in Nineteenth-century Japanese Prints', *Impressions*, no. 23 (2001), pp. 42–63

Holborn, Mark, *Beyond Japan: A Photo Theatre* (London, 1991)

——, *Black Sun: The Eyes of Four: Roots and Innovation in Japanese Photography* (New York, 1986)

Howard Greenberg Gallery and Charles Schwartz Ltd, *Art Photography in Japan, 1920–1940* (New York, 2003)

Howell, David L., *Geographies of Identity in Nineteenth-century Japan* (Berkeley, CA, 2005)

Iizawa, Kōtaro, ed., *Fukuhara Shinzō to Fukuhara Rosō* (Tokyo, 1999)

——, *Fuchikami Hakuyō to Manshū shashin sakka kyōkai* (Fuchikami Hakuyō and the Photographers in Manchuria) (Tokyo, 1999)

——, *Yamahata Yōsuke* (Tokyo, 1998)

Inoue, Shōichi, *Bijin kontesuto kyakunenshi: geigi no jidai kara bishojo made* (One Hundred Years of Beauty Contests: From Geisha to Beautiful Girls) (Tokyo, 1992)

'Japanese American Pictorialist Photography', in *Asian American Modern Art: Shifting Currents, 1900–1970*, ed. Daniell Cornell and Mark Dean Johnson (San Francisco, CA, 2008), pp. 64–73

Jenkins, Rupert, ed., *Nagasaki Journey: The Photographs of Yosuke Yamahata, August 10, 1945* (San Francisco, CA, 1995)

Jones, Peter C., 'Japan's Best-Kept Secret: Japanese Ambrotype Portraits', *Aperture*, 138 (1995), pp. 75–8

Kaneko, Ryūichi, *Modern Photography in Japan, 1915–1940* exh. cat., Ansel Adams Center, San Francisco, (2001)

Keene, Donald, 'Portraits of the Emperor Meiji', *Impressions*, 21 (1999), pp. 17–29

Kikai, Hiroh, *Hiroh Kikai: Asakusa Portraits* (New York, 2008)

Kinoshita, Naoyuki, 'Portraying the War Dead: Photography as a Medium for Memorial Portraiture', in *Reflecting Truth: Japanese Photography in the Nineteenth Century*, ed. Nicole Rousmaniere and Mikiko Hirayama (Leiden, 2004)

——, *Shashin garon: shashin to kaiga no kekkon* (On Photographic Pictures: The Marriage of Photography and Painting), exh. cat., Tokyo Metropolitan Museum of Photography, Tokyo (1996)

Kiss in the Dark: Contemporary Japanese Photography, exh. cat., Tokyo Metropolitan Museum of Photography, Tokyo (2002)

Kobe modanizumu no kōsai: Nakayama Iwata (Luminous Colours of Kobe Modernism: Iwata Nakayama), exh. cat., Ashiya City Museum of Art and History, Ashiya (1996)

Kuraishi, Shino, 'The Membrane of Cities and Architecture: Takashi Homma's Photographs', *Camera Austria International*, 77 (2002), pp. 4–15

Lewis, Gordon, ed., *The History of the Japanese Camera* (Rochester, NY, and Tokyo, 1991)

Liquid Crystal Futures: Contemporary Japanese Photography, exh. cat., Fruitmarket Gallery, Edinburgh (1994)

Low, Morris, *Japan on Display: Photography and the Emperor* (London and New York, 2006)

Maggia, Filippo, *Instant City* (Milan, 2001)

Masuda, Rei, and Shogo Otani, eds, *Takanashi Yutaka: Hikari no fieldnote* (Yutaka Takanashi: Field Notes of Light), exh. cat., National Museum of Modern Art, Tokyo (2009)

Masuda, Rei, ed., *Gochō Shigeo: A Retrospective*, exh. cat., National Museum of Modern Art, Tokyo (2003)

Menzies, Jackie, ed., *Modern Boy Modern Girl: Modernity in Japanese Art, 1910–1935*, exh. cat., Art Gallery of New South Wales (Sydney, 1998)

Miki, Akiko, Yoshiko Isshiki and Tomoko Sato, eds, *Nobuyoshi Araki: Self, Life, Death* (London, 2005)

Miller, Laura, 'Bad Girl Photography', in *Bad Girls of Japan*, ed. Laura Miller and Jan Bardsley (New York, 2005), pp. 127–42

Modern Photography: Iwata Nakayama Retrospective exh. cat., Ashiya City Museum of Art and History, Ashiya (1996)

Moriyama, Daidō, *Shashin yo sayonara* (Tokyo, 1972)

——, Shinjuku, *19xx-20xx* (Tokyo, 2006)

——, *Shinjuku* (Tucson, AZ, 2002)

——, Alexandra Munroe and Sandra Phillips, *Daido Moriyama: Stray Dog*, exh. cat., San Francisco Museum of Modern Art (San Francisco and New York, 1999)

Morris-Suzuki, Tessa, *The Past Within Us: Media, Memory, History* (New York, 2005)

Morse, Anne, et al., *Art of the Japanese Postcard*, exh. cat., Museum of Fine Arts, Boston (2004)

Naoya Hatakeyama (Ostfildern-Ruit, 2002)

Nihon gendai shashinshi 1945–95 (History of Contemporary Japanese Photography, 1945–95) (Tokyo, 2000)

Nihon kindai shashin no seiritsu to tenkai (The Founding and Development of Modern Photography in Japan), exh. cat., Tokyo Metropolitan Museum of Photography, Tokyo (1995)

Nihon shashin zenshū (The Complete History of Japanese Photography), 12 vols (Tokyo, 1985–88)

Nihon shashinshi gaisetsu (Survey of the History of Japanese Photography), (Tokyo, 1999)

Nojima Yasuzō to sono shūhen: Nihon kindai shashin to kaiga no hitotsu danmen (Yasuzo Nojima and Contemporaries: One Aspect of Modern Japanese Photography and Paintings), exh. cat., National Museum of Modern Art, Kyoto (1991)

Notehelfer, F. G., 'Burton Holmes, the Camera and the Russo-Japanese War', *Asian Art*, VI/1 (1993), pp. 51–9

Odo, David R., 'Expeditionary Photographs of the Ogasawara Islands, 1875–76', *History of Photography*, XXXIII/2 (2009), pp. 185–208

Ozawa, Kenji, *Koshashin de miru bakumatsu Meiji no bijin zukan* (Seen through Old Photos: Bakumatsu Meiji Picture Book of Beauties) (Tokyo, 2001)

——, ed., *Shashin: Meiji no sensō* (Photography: Meiji War) (Tokyo, 2001)

Ozawa, Takeshi, *Nihon no shashinsh* (The History of Japanese Photography) (Tokyo, 1986)

Padon, Thomas, ed., *Truth Beauty: Pictorialism and the Photograph as Art, 1845–1945*, exh. cat. Vancouver Art Gallery (2008)

Reed, Dennis, *Japanese Photography in America, 1920–1940* (Los Angeles, CA, 1985)

——, 'The Wind Came from the East: Asian American Photography, 1850–1965', in *Asian American Art: A History, 1850–1970*, ed. Gordon H. Chang, Mark Dean Johnson and Paul J. Karlstrom (Stanford, CA, 2008), pp. 141–67

Reynolds, Jonathan, 'Ise Shrine and a Modernist Construction of Japanese Tradition', *Art Bulletin*, LXXXIII/2 (2001), pp. 316–41

Ryuji Miyamoto (Göttingen, 1999)

Saitō, Takio, *Bakumatsu Meiji Yokohama Shashinkan Monogatari* (The Story of Yokohama Bakumatsu-Meiji Photography Studios) (Tokyo, 2004)

Sharf, Frederick, et al., *A Much Recorded War: The Russo-Japanese War in History and Imagery*, exh. cat., Museum of Fine Arts, Boston (2005)

Shashin torai no koro (The Advent of Photography in Japan), exh. cat., Tokyo Metropolitan Museum of Photography, Tokyo (1997)

Siegel, Elizabeth, *Photo-Respiration: Tokihiro Sato Photographs* (Chicago, IL, 2005)

Sorensen, André, *The Making of Urban Japan: Cities and Planning from Edo to the Twenty-first Century* (London, 2002)

Stearns, Robert, et al., *Photography and Beyond in Japan: Space, Time and Memory* (Tokyo and New York, 1995)

Szarkowski, John, and Shoji Yamagishi, *New Japanese Photography*, exh.cat., The Museum of Modern Art, New York (1974)

Thomas, Julia Adeney, 'Photography Exhibitions and Japanese National Identity', in *Museums and Memory*, ed. Susan Crane (Stanford, CA, 2000), pp. 93–114

——, 'Global Culture in Question: Contemporary Japanese Photography in America', in *Globalizing Japan: Ethnography of the Japanese Presence in Asia, Europe and America*, ed. Harumi Befu and Syvlie Guichard-Anguis (London and New York, 2001), pp. 131–49

——, 'The Unreciprocated Gaze: Emperors and Photography', in *The Emperors of Modern Japan*, ed. Ben-Ami Shillony (Leiden, 2008), pp. 185–210

——, 'Power Made Visible: Photography and Postwar Japan's Elusive Reality', *Journal of Asian Studies*, LXVII/2 (2008), pp. 365–94

——, 'Photography, National Identity and the "Cataract of Times": Wartime Images and the Case of Japan', *American Historical Review*, CIII/5 (1998), pp. 1475–1501

——, 'Raw Photographs and Cooked History: Photography's Ambiguous Place in the National Museum of Modern Art, Tokyo', *East Asian History*, no. 12 (1998), pp. 121–34

Tokyo Dream Tales (Tokyo, 2007)

Tseng, Alice Y., *The Imperial Museums of Meiji Japan: Architecture and the Art of the Nation* (Seattle, WA, 2008)

Tucker, Anne Wilkes, ed., *The History of Japanese Photography*, exh. cat. Houston Museum of Fine Arts (Houston, TX, and New Haven, CT, 2003)

Utsusareta kokuhō: Nihon ni okeru bunkazai shashin no keifu (Image and Essence: A Genealogy of Japanese Photographers' Views of National Treasures), exh. cat., Tokyo Metropolitan Museum of Photography, Tokyo (2000)

Vartanian, Ivan, *Takashi Homma: Tokyo, A Collection of Photographs* (New York, 2008)

——, ed., *Setting Sun: Writings by Japanese Photographers* (New York, 2006)

—— and Ryūichi Kaneko, *Japanese Photobooks of the 1960s and '70s* (New York, 2009)

Wakita, Mio, 'Selling Japan: Kusakabe Kimbei's Images of Japanese Women', *History of Photography*, XXXII/2, pp. 209–23

Wallis, Jonathan, 'The Paradox of Mariko Mori's Women in Post-Bubble Japan: Office Ladies, Schoolgirls and Video Vixens', *Women's Art Journal*, XXIX/1 (2008), pp. 3–12

Watanabe, Toshio, 'Josiah Conder's Rokumeikan: Architecture and National Representation in Meiji Japan', *Art Journal*, VXV/5 (1996), pp. 21–7

Weisenfeld, Gennifer, 'Touring Japan-As-Museum: NIPPON and Other Japanese Imperialist Travelogues', *positions*, VIII/3 (2000), pp. 747–93

Wong, Ka F., 'Entanglements of Ethnographic Images: Torii Ryuzo's Photographic Record of Taiwan Aborigines (1896–1900)', *Japanese Studies*, XXIV/3 (2004), pp. 283–99

Yasumasa Morimura, *Daughter of Art History: Photographs by Yasumasa Morimura* (New York, 2003)

Acknowledgements

This project was initiated by Michael Leaman of Reaktion while I was
a Robert and Lisa Sainsbury Fellow based at the School of Oriental
and African Studies at the University of London. I am especially grateful
to Michael, and I would also like to thank series editor Mark Haworth-
Booth and project editor Blanche Craig.

I am indebted to the Sainsbury Institute for the Study of Japanese
Arts and Cultures for their financial support and to both SISJAC and
SOAS for fostering such a fruitful intellectual climate. Special thanks
are due to John Carpenter, Nicole Coolidge Rousmaniere, Simon Kaner,
Timon Screech, Kazuko Morohashi, Akira Hirano and to all of the
SISJAC staff. While in London I spent many enjoyable hours perusing
photographic materials at the British Museum, a luxury facilitated by
Tim Clark, Rosina Buckland and Hiromi Uchida. Several trips to Maggs
Bros to examine the early twentieth-century photographic books and
journals expertly compiled by Titus Boeder were another highlight of
my fellowship year.

A Dean's Grant from the College of Arts and Sciences at Santa Clara
University provided generous funding for this project. Grants from the
Association for Asian Studies North East Asia Council and the Kyoto
Metropolitan Center for Far Eastern Art Studies supported travel and
research in Japan.

Sakiko Kito provided invaluable assistance tracking down images
and securing copyright permissions. Without her, the project would
have been considerably delayed, and I am extremely grateful for her
industriousness and good humour. Katrina Liebl and Elwood Mills
were also helpful in procuring images. Additionally I would like to
thank Monika Hinkel, Mikiko Hirayama, Maki Fukuoka, Philbert Ono,
Pauline Ota, Chiyo Honde and my colleagues in the Department of Art
and Art History at Santa Clara University for their advice and support.

Photo Acknowledgements

The author and publishers wish to express their thanks to the following sources of illustrative material and/or permission to reproduce it:

Asahi Shimbun Photo Archive: 36, 74; Daidō Moriyama and Taka Ishii Gallery: 93–4; Domon Ken Museum: 76; Eikoh Hosoe: 13–14; Hakodate City Central Library: 24; Hakodate City Museum: 25; Henry and Nancy Rosin Collection of Photographs of Japan, Freer Gallery of Art and Arthur M. Sackler Gallery Archives, partial purchase and gift of Henry and Nancy Rosin, 1999–2001: 20; Hiroh Kikai: 104; Hiromi Tsuchida: 42, 98; Iwata Nakayama Foundation and Ashiya City Museum of Art and History: 17, 87; © Ikko Narahara: 12, 44; Izu Photo Museum: 28; Japan Professional Photographers Society: 30; JCII Camera Museum: 62; JCII Camera Museum, © Naoko Kimura: 90; Kanagawa Prefectural Museum: 83; Kaoru Ishimoto: 81; © Keisuke Katano: 10–11, 43; Keizō Kitajima: 100; © Kikuji Kawada, courtesy of the artist: 78–9; Koishi Kiyoshi estate: 32; Kunaicho (Imperial Household Agency): 18–19; Mainichi Shimbunsha: 59, 60, 66; Mariko Mori and Art Resource, NY, © Mariko Mori: 47; Miwa Yanagi and Sammlung Deutsche Bank: 49; Miwa Yanagi and Yoshiko Isshiki: 48; Museum of Fine Arts, Boston, Gift of Jean S. and Frederic A. Sharf, photograph © 2011: 84; Museum of Fine Arts, Boston, Jean S. and Frederic A. Sharf Collection, photograph © 2011: 63; Museum of Fine Arts, Boston, Leonard A. Lauder Collection of Japanese Postcards, photograph © 2011: 65; © Naoko Kimura: 91; Naoya Hatakeyama and Taka Ishii Gallery: 101; National Park Service, Longfellow National Historic Site: 31; Nobuyoshi Araki and Taka Ishii Gallery: 46; Old Japan Picture Library: 4, 21, 56; Pola Research Institute of Beauty and Culture: 29; Private collections: 5, 38, 86; Reed Collection: 33; Sebastian Dobson: 64; Setagaya Art Museum, Tokyo: 7; Shibusawa Memorial Museum: 22; Shiseido Corporate Museum: 34; Shogo Yamahata: 72–3; © Shoji Ueda Office: 16; Shōkoshūsei-kan: 3; Shōmei Tōmatsu: 77, 92, 95; Shunan City Museum of Art and History: 75; Smith College Museum of Art, Northampton Massachusetts. Purchased with the Hillyer-Tryon-Mather Fund, with funds given in memory of Nancy Newhall (Nancy Parker, class of 1930) and in honour of Beaumont Newhall, and with funds given in honour of Ruth Wedgwood Kennedy: 57; Tadahiko Hayashi estate: 69; Takashi Homma: 99; Taro Nasu, © Ryūji Miyamoto 1995: 102; The National Museum of Modern Art, Kyoto: 35; The Pace Gallery, © Hiroshi Sugimoto: 1; The Third Gallery Aya and Masato Miura: 97; The Third Gallery Aya, © Midori Komatsubara: 53; The Third Gallery Aya, © Naoki Kajitani: 103; The University Museum, The University of Tokyo: 26–7; Tokihiro Satoh: 82; Tokyo Metropolitan Museum of Photography and Tarui Kunihiko: 8; Tokyo Metropolitan Museum of Photography and Kazuo Watanabe: 40–41; Tokyo Metropolitan Museum of Photography and Masahisa Fukase Estate: 45; Tomishige Photo Atelier Collection: 58; Tomohiro Kageyama: 89; © Tomoko Sawada, Courtesy MEM, Tokyo and Zabriskie Gallery, New York: 50–52; Toyo Miyatake Collection: 71; Trustees of the British Museum: 68; US Library of Congress: 39; UPI/KYODO: 80; Yasumasa Morimura and Luhring Augustine, New York: 54; Yokohama Museum of Art: 85; Yumiko Chiba Associates and Zeit-Foto Salon, © Ryudai Takano: 15; Yutaka Takanashi and The National Museum of Modern Art, Tokyo: 96; © Yurie Nagashima: 2.

Index